Creative Woodburning

Creative Woodburning

Projects, Patterns & Instructions
to Get Crafty With Pyrography

Bee Locke

DK

Contents

ABOUT THE AUTHOR

Bee Locke is a self-taught pyrography artist with 10 years of experience and a thriving creative woodburning business based out of her home studio in the Blue Ridge Mountains. Her nature-inspired woodburned artwork is renowned for its intricate detail and has been featured in such publications as *Carolina Home & Garden* and *Asheville Made* as well as at many of the craft shows in her local region.

Bee lives on a beautiful raspberry farm in rural North Carolina with her husband, their daughter, and two dogs. When she isn't woodburning or selling her work at shows, she enjoys birdwatching and basketweaving. You can see more of her work at www.beesymmetry.com.

Introduction

Thank you for taking the first step in opening this book to learn and grow as a student of pyrography!

Are you interested in woodburning but don't know where to begin? Are you overwhelmed by the array of tools available and how to properly use them? Do you want to finally learn the best ways to transfer designs onto wood, unlock the mysteries of finishing and sealing, or flawlessly add color to your woodburned artwork? I can help!

Whether you're a beginner wanting to learn the basics or an experienced pyrographer wanting to improve your techniques, there's something for everyone in this unique book!

As a lifelong artist and lover of making things with my hands, I absolutely fell in love when I discovered pyrography. Beginning with just an old soldering iron, I quickly realized woodburning has more to offer me than almost any other art form. What began as a beloved hobby grew into a business over the years. When my daughter was born, I was in a position to work from home out of necessity. I took my love for woodburning and slowly turned it into an income for my family. More than 10 years ago, this spark of interest was lit—and it has been kindled ever since.

Like many beginners, I found myself frustrated with the results I was getting with my woodburned art and I knew I had the potential to make better, higher-quality artwork. Through years of trial and error and many breakthroughs, I discovered some

tried-and-true techniques that consistently give beautiful results and are simple enough for novice woodburners to understand and implement. With the wisdom gleaned from experience, I'm honored to share with you many straightforward guidelines you can begin incorporating into your woodburning today! You don't have to struggle for years to perfect your own methods, you don't need to have expert drawing skills, and you don't need to spend a lot of money to create polished, professional-quality woodburning.

I'm so excited to share my insights as a self-taught pyrographer so you can learn and fall in love with this enticing art form as I have. Come along with me as I share simple, effective techniques for turning the ideas in your imagination into impressive woodburned artwork. I guide you through everything from selecting the right tools and materials to burning your designs effectively and beautifully to sealing your final product. From easy-to-understand tips and tricks and inspiring new project ideas to answers to the most frequently asked questions, you'll learn as you go and sharpen your skills in the process.

You'll learn how to create 20 step-by-step projects, which will test and broaden your pyrography skills, giving you the experience and confidence to keep learning more! Dive into shading, stippling, linework, and lettering. Discover the best methods for creating realistic woodburned fur, scales, feathers, and more. And enjoy more than 180 original hand-drawn templates for you to trace and transfer onto your own projects!

Even after a decade of woodburning, I'm constantly learning! This art form never fails to intrigue, delight the senses, and make space for growth and experimentation. For those of us who crave versatility and newness in our art, I can think of no better art form to ignite and satisfy that inner calling than pyrography.

As a major passion in my life, pyrography has led to many enriching opportunities and connections, for which I'm so grateful. Writing this book has been a cherry on top of a wonderful decade of woodburning. Art inspires and connects us, and where there's a creative calling, there's room for fulfillment and so much fun!

Keep reading to discover the keys to using your woodburning tools to their fullest potential!

Chapter 1
Lighting the Fire

What Is Pyrography?

Technically speaking, pyrography is the method of burning designs onto wood or other materials using the controlled application of heat, typically from an electrically heated metal implement or the flame from a torch. Also known as woodburning, pyrography builds on the basic principles of drawing and amplifies it with the tactile infusion of heat onto natural surfaces and its perfect suitability to beautifying functional, everyday objects. Pyrography isn't limited to wooden surfaces alone. Many natural materials can be safely burned, such as paper, gourds, and leather. For this book, the emphasis is mostly on wood pyrography, with techniques for honing your skills across an array of wood types and subject matters.

WHO CAN WOODBURN?

Widely celebrated for its versatility, woodburning can open the door to a whole new world of artistic possibilities for anyone with a creative inkling. Although it's long been considered merely a "craft," pyrography is quickly becoming recognized as a skilled art form and many artists choose this medium to create their works of fine art. Woodworkers enjoy incorporating burned details into their handmade creations—just as pyrographers enjoy finding new wooden objects to decorate. Jewelry makers, upcyclers, and fine craftspeople alike can find a place for woodburning in their work. From absolute beginners to experienced artisans, hobbyists to professionals, woodburning offers something for everyone.

Through the ages, humans have enjoyed creating art with burned tools—such as sticks turned to char—and our modern advancements have dramatically enhanced the experience of making burned art more precisely, intricately, and easily than ever before! Pyrographers nowadays will enjoy using a whole host of specialized tools to create their artwork, including heated metal pens of various shapes as well as hot air and torch flames. As woodburning has grown in popularity, the array of tools on the market has also expanded. Whether you want to create simple or ornate designs, you can find the right pyrography tools to suit your needs no matter your budget.

Working with the element of fire and with "canvases" of natural materials makes pyrography more sensory than your average art form and adds an earthy touch to the final product. Each piece of wood is unique and will behave slightly differently under the influence of a burning tool. Over time, learning the patterns and interplay between the heat from your tool and the wooden surface is a rewarding journey that can yield some gorgeous results. Much like drawing or painting, woodburning is a skill you can hone and master over time. Even after years of experience, many pyrographers find they continue to learn more with each species of wood and each new tool they use! There's always room for growth, experimentation, and unique collaborations within the world of woodburning.

Pyrography is a fun, versatile, satisfying art form that will capture your imagination for years to come if you let it!

Tools of the Trade

I began my woodburning journey with an old soldering iron and I've since worked my way up the proverbial stepladder of pyrography machine styles. I can tell you from experience that no matter what tool you have, you can create something beautiful—and you can have fun doing it! Like me, you might decide to get your toes wet with a simpler tool, and if the love of pyrography ignites within, you can choose to upgrade to a tool that can grow along with your skill level. The better the quality of the tool you have, the better your artwork will be and the easier it will be to bring your unique visions to life. A large part of creating great woodburned artwork is knowing your tool well and taking full advantage of what it has to offer you. Let's learn more about the essential tools for woodburning.

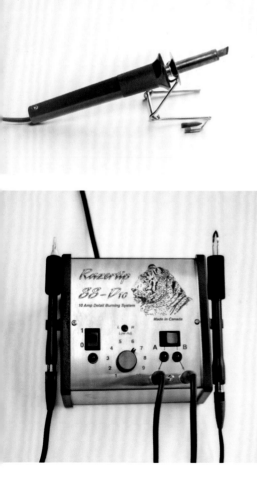

PYROGRAPHY MACHINE STYLES

Starter Kits

Many affordable options for the home pyrography hobbyist exist these days. Much to your luck, you can buy a simple woodburning kit with interchangeable tips for around $30. Usually, these styles of pens plug directly into the wall, with a cord coming directly out of the end of the pen. They might come with a stand and they'll likely come with tips that screw in and out of the end of the pen. Be careful to only change the tips when the tool is cooled down or you risk stripping the threads of the screw portion.

One drawback of these beginner-friendly tools is they typically don't come with the ability to adjust the temperature. With the addition of a temperature dial, the doors open to much more control and detail in your woodburning.

Higher-Quality Options

If you want to dive into the art of woodburning, I recommend investing in the best-quality tool you can from the get-go. There are a lot of great pyrography machines on the market, and of all the machines I've tried, I'm most impressed with the Razertip systems. I have used a Razertip SS-D10 unit for many years and it's a consistent, reliable, and professional-quality machine. (Many comparable pyrography machines exist, but because I use and love Razertip products, all the woodburning in this book was done with a Razertip machine and pens.) You don't have to be a professional pyrographer, though, to enjoy the benefits of a higher-quality woodburning unit. The temperature sensitivity, wide array of tips and pens available, and long-lasting durability are features anyone can appreciate. Typically, higher-quality woodburning machines come as a base unit with ports that can connect to one or more pens via an electrical cord.

PENS & TIPS

The absolute most crucial and fundamental tools in the world of pyrography are the pens and tips you use. The right tip shape used in the right way can make your project go from mediocre to magical in short order. The following pages describe how you can best utilize each tip style to achieve the effect you're going for in your own artwork.

Pro tip (pun intended): If you're a beginner looking for the best basic pens to get you started, here's what I recommend: Choose one flat-bottomed angled shading tip, one curved shading tip, one medium-sized ball tip, one writing tip, one fine detail tip, and one curved knife tip. What pen style you choose is up to your own preference and budget. If you have those six basic tools to work with, you'll be able to create all the burned imagery shown in this book—and more!

Fixed-Tip Pens

Fixed-tip pens are pyrography pens that have the tip fused to the body of the pen. The tip isn't removable. To change the pen you're using, simply unhook the cord from the end and plug in a different pen. They tend to be a durable option for those tip shapes you can't live without, minus the fuss of changing tips.

Interchangeable Pens

Interchangeable pens allow you to change out the tip using a screwdriver. Simply remove the screws, slide out the tip, and replace it with the new one you want to use. The base pen is universal and the tips can be purchased separately. The tool should be turned off and cooled before changing the tips. These are more affordable than fixed-tip pens and they're compact for saving space. There are dozens of tip shapes compatible with the interchangeable BPH pens from Razertip.

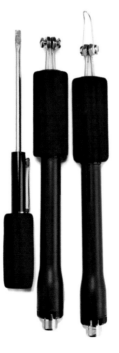

Angled Shading Tips

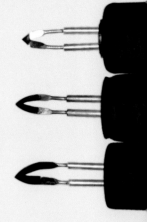

Angled shaders are used to shade in spaces having straight lines or sharp angles or in places where precision is important. The edge of an angled shader can be used to create a sharp, straight line and these also make great tips for achieving solid black backgrounds. Any angled shader will have a flat bottom and come to a sharp, triangular point in front. These are versatile tips and great for shading bold contrasts.

Curved Shading Tips

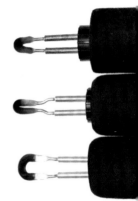

Curved shading tips are best used to shade in areas without sharply defined edges, in rounded spaces, or for ethereal subjects: clouds, smoke, bubbles, water, mist, fluffy fur, foliage, portraits, blurry backgrounds, and more. These tools are typically used on low heat and by moving the tool in small circles. The heat is built up slowly for light and subtle shading.

Knife Tips

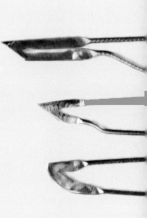

These are the go-to tools for perfectly straight lines every time. They easily slice through finicky wood grain and are the best tools for creating crosshatching patterns, geometric designs, intricate linework, or just plain simple outlines and borders. I use a curved knife most of all, but any knife-shaped tip is great for these purposes. The long knife (also called a skew) is the perfect choice for cutting into gourds.

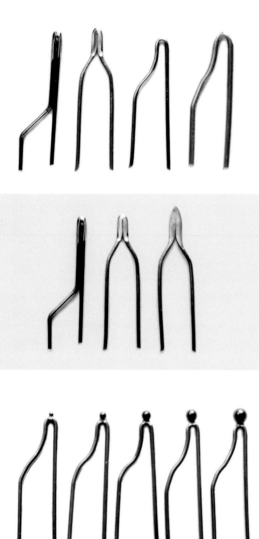

Writing Tips

Writing tips are rounded on the bottom and specialized to create a smooth, even line when used like a pencil. Not only great for text, writing tips are perfect for creating uniform outlines, details, and textures requiring the freedom of movement over and across the grain of the wood without catching or snagging.

Fine Detail Tips

These are tips that are very fine, either pointed or rounded, and small enough to fit into the tiniest of spaces. Fine detail tips are best used on low heat so you can be as precise as possible with your strokes. They're not for creating large straight lines or shading because the small surface area of the point will easily sink into the wood, causing unevenness. Often, these tips are used first for thin outlining or last to really fine-tune the finishing touches of an art piece.

Ball Tips

Ball tips come in many sizes—from tiny to quite large. The bigger the steel ball on the end of your tip, the longer it will take to heat up and the larger the dot it makes will be. These tips are used to achieve a stippling effect, which is akin to woodburned pointillism. Ball tips can also be used similarly to writing tips in certain cases. The rounded bottom will create a round impression in the wood when you burn with it, leaving a pleasing texture behind.

Transfer Shaders

These tools are specifically designed to accomplish even heat transfers of templates onto your woodburning. They're basically like tiny clothing irons, wiping across the surface of the paper and heating the toner so your image is transferred perfectly. Of course, you can also use these as leaf-shaped stamps or for shading in solid black areas.

NOTE: In pyrography terminology, the difference between pens and tips is as follows. A "pen" refers to the entire implement you hold in your hand while woodburning. It can have either fixed or interchangeable tips. A "tip" refers to the shaped metal end of the pen that heats up and is used to burn marks onto the wood. All pens have tips and all tips must be attached to a pen.

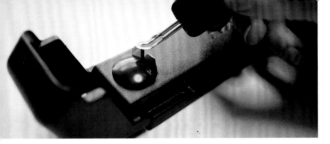

TOOL MAINTENANCE & CARE

Tool Scrapers

It's important to keep your tools clean while in use. Using a tool scraper can help keep carbon from building up on your heated tip and allow you to burn more smoothly and efficiently. If carbon starts to build up on your tip, you'll notice the difference in the way the tool feels as it runs across the wood. It might feel and look rougher, and there might be pieces of carbon that flake off at random and burn up or get stuck to the surface of the wood. By keeping a tool scraper nearby while you're woodburning, you can easily remedy this common issue.

There are two different styles of tool scrapers. One features a sturdy base supporting two blade-like pieces of steel you can scrape your tool against. It's shaped somewhat like a knife sharpener so you can use the various angles to make sure all the surfaces of your tool are clean. The other is a brass brush with brass bristles you can simply rub back and forth against your tool to clean off the carbon. A brass brush is especially effective for ball-shaped or curved tips or for tips with small hard-to-reach spots. Both tool scrapers can be used safely while your tool is hot. Other things you could use to scrape your tool that you might already have at home include a metal mesh strainer, any straight-edged knife, or steel wool.

GOOD HABITS OF TOOL CARE

Developing some routines around caring for your tools will help them maintain their longevity and ultimately save you money and time in the long run. Remember that your tools are what truly enable you to create the beautiful woodburned creations you love and they do need some attention now and then.

- Before you begin woodburning, make sure all your cords are properly connected and plugged in all the way. This ensures the electrical current running through your machine creating heat has the proper connection and the heat is travelling efficiently. Inefficient or improperly connected wires have the potential to burn you, melt your cord, or overwork your machine, so this 10-second double-check is well worthwhile.

- Don't press too hard with your tools. One challenge for beginners is overriding that natural inclination to press down too hard with your tools on the wood. Using too much pressure will ultimately bend and weaken your tools. You should only use enough pressure to let your pen come into full contact with the wood and let the heat from the pen do the work for you.

- If your tools are getting carbon buildup, it's a good idea to give them a good sanding with lightly abrasive sandpaper to dislodge any buildup and create a smooth, shiny surface, which will give you a smooth burn. You can also use a tool scraper to clean your tools.

- If your machine becomes dusty over time, unplug it from the power source and let it cool before gently wiping it down with a damp towel. Getting grit into the crevices of your machine can gum up the functions over time and it's better to be safe than sorry.

- When not in use—and for long-term storage and durability—keep your tools in a covered place, such as a box, a bin, a drawer, or somewhere they'll be protected from dust and other debris.

- Remember, the better you care for your tools, the better they'll work for you!

Selecting the Right Materials

With the popularity of woodcrafts rising, you can easily find quality materials for woodburning. You can buy ready-to-burn materials from your local hardware store, the woodcraft aisle of your local hobby store, or from an online retailer that sells prepared wood for pyrography. If you're the DIY type, you could even cut your own wood or purchase low-cost wood from a sawmill and then dry and cure it yourself. I recommend beginners get started in woodburning with some good-quality kiln-dried basswood for its affordability and the absolute ease with which it can be burned. You can find basswood at most nationwide hobby stores that sell woodcraft products.

WHAT TO LOOK FOR WHEN CHOOSING WOOD

Making sure the wood you choose is of an appropriate quality will have a positive effect on the end result of your creation. The following pages detail major characteristics to compare when selecting the right materials.

Kiln-Dried Wood

Kiln-dried wood is the best in my opinion. Kiln-dried wood has been cut up and then dried in a kiln (basically, a large, hot oven) to speed up the drying time. Traditionally, after a tree is cut, the wood needs to sit and cure for a year (or more!) in a low-humidity room to slowly dry out. It's time-consuming and not foolproof, so this method can yield wood with cracks and splits, rendering the wood practically useless for woodburning. Or if the wood fails to dry out completely, it can become host to mold or mildew. Remember, wood is a natural material and is thus food for living organisms. Moisture is the enemy when it comes to keeping wood beautiful. Kiln-dried wood is a more consistently reliable product overall and most prepared wood products you'll find in a craft supply store are dried this way.

Raw/Unfinished Wood

You know wood is safe for burning if it's raw and unfinished solid wood. "Unfinished" means no sealing products have ever been applied to the wood and that the wood is in its natural dried state. If you want to burn anything that has previously been finished/sealed, such as repurposed cabinets, kitchenware, furniture or the like, you'll have to sand several layers off the surface of the wood before beginning and proceed with caution and plenty of ventilation. Remember, sawdust is a lung irritant, so always wear a respirator while sanding. Pressure-treated or chemically treated woods aren't considered raw or unfinished and should be avoided.

Cracks and Splits

If the wood is cracked or has a split, don't burn on it. You want to use wood that's solid and intact for your woodburning projects. The temperature variation caused by applying heat to the wood surface makes the pores expand and contract. If there's a split in the wood, this temperature fluctuation can cause the split to travel deeper into the wood.

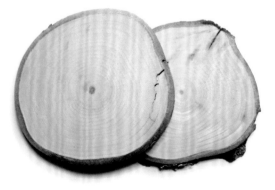

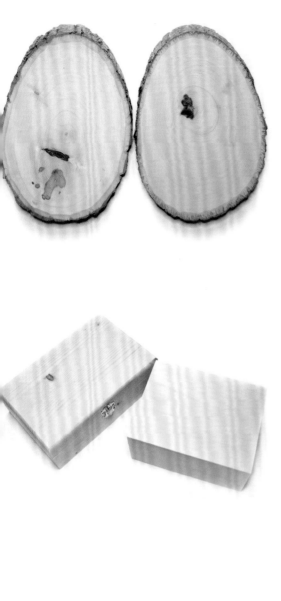

Knots and Discoloration

Take notice of any large knots or areas of discoloration in the wood. The density and composition of the wood fibers can be much different within a burl or a knot in the wood, so it will affect the way it burns. Having a dark spot or a knot in the wood—like in the photos at left— isn't a deal-breaker if you can think of a way to creatively incorporate the spot into the composition of your artwork. Sometimes, a well-thought-out art piece incorporating a natural anomaly in the wood is appealing and brings added visual interest to your work. The two plaques in the photo at left are of great quality and have sections of naturally darker, denser wood. You don't need to discard these pieces if you have them because they can still be used to make something beautiful.

Grain Pattern

Generally, I avoid wood with a prominent grain pattern. The best woods for woodburning are those with softer and less noticeable grain. The grain pattern can change from piece to piece depending on how the wood grew within the tree and how it has been cut, so looking at each piece individually can help you determine whether the wood will work for your purposes. Consider the photo at left. The box on the left is pine and the box on the right is basswood. You can see the tight, stripey grain on the pine box. If you were to scrape your fingernail across the surface, it would skip over each grain stripe like you were playing a washboard. If you were to run your fingernail across the basswood box, it would slip smoothly without snagging on anything. This particular pine box is a poor choice for woodburning because your tool is going to get stuck on every line of grain showing—just the way your fingernail did. In this case, I'd absolutely choose the basswood box.

Just Say No to Resin

Several species of trees in North America contain resin within their wood. When heat from your tool is applied to an area with resin, the resin can bubble up out of the wood and create a sticky, gummy layer on the surface, making it virtually impossible to burn the wood properly. And most importantly, when resin burns, it releases harmful smoke that's damaging to your lungs. Refer to the picture of the plaques at left. One has a large, dark orangey band across it and the other doesn't. The orange stripe is a pocket of resinous wood. You can tell because this is pine and also because the coloration has a slight sheen to it if you angle it just right. This sheen is caused by the resin present within the wood fibers. If I were choosing which of these pine plaques to use for my project, I'd choose the one without the thick resinous band for better results.

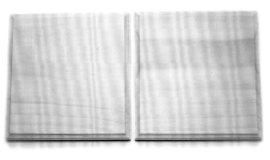

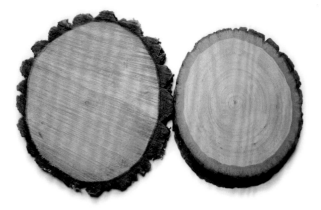

Texture

The best surfaces for woodburning are soft and smooth to the touch. The smoother your surface, the smoother your shading and lines will be when burned. Any rough texture on your surface will inevitably affect your ability to woodburn it. If the surface of the wood is basically flat and level with just a slight roughness, you can remedy that by rubbing it with 220 grit sandpaper until it's the smoothness you need. However, if the wood has large gouges or is rough to the touch, it will either need to be planed and sanded down to a smooth finish or you should simply choose a different surface.

You can see the two wood discs above have different textures on their surfaces. The disc on the left has been cut by hand, naturally dried, and given to me, while the disc on the right has been kiln-dried and pre-sanded and was purchased at a craft supply store. The disc on the left is practically useless for pyrography. No manner of sanding will help this jagged surface. In this case, I'd absolutely choose to use the smooth, sanded surface of the right disc.

MDF—A WARNING!

MDF, or medium-density fiberboard, is commonly sold in hobby stores as small cutout shapes. MDF is a condensed wood pulp product held together by industrial adhesives. If you burn MDF, you'll also be burning the adhesive. This glue not only gives off noxious nose-ruffling odors, but it's also extremely toxic to your lungs and contains carcinogenic (cancer-causing) ingredients. You should *never* use MDF for woodburning. Stick with solid wood options.

SPECIES OF WOOD

I focus here on the common North American tree species used for pyrography. By no means is this an exhaustive list of all the woods you could use for your projects.

Basswood

My favorite wood to burn on—period. This wood is perfect for pyrography with its smooth, buttery texture, light color, light but solid density, and evenly absorbent quality. This wood soaks up color evenly and is generally a great choice for any woodburning project. You can often find basswood plaques with the bark still attached, which gives a charming rustic look to your pieces. This wood is great for beginners because there are no issues to beware of and you can work on building your skills uninhibited by pesky wood grain or finicky resin pockets or any other wood textures you might come across with other species. Basswood is a moderately priced wood with wide availability and is worth paying slightly more for.

Poplar

Poplar is an overall good choice for pyrography. It's a light wood without being too soft and is a commonly found wood species. Poplar can have a naturally yellowish tinge to it, which will be even more evident once sealed, so it's a good candidate for those projects using wood stain or other colors. It burns evenly and I usually have to burn with a slightly higher heat on poplar than on basswood. The grain pattern is smooth and unproblematic.

Birch

Birch is a beautiful wood that burns nicely. Another light-colored wood, it's most often available as a plywood veneer. Birch plywood sheets are affordable and beautiful "canvases" for larger pyrography projects. Birch wood usually needs a good sanding. The fibers of the wood can flake off in linear pieces and fray, so it's a good idea to sand your birch well before woodburning so your shading will cover the surface evenly.

Maple

Maple is a wonderful wood to burn on. With its beautiful light waves of color throughout, it's an elegant and durable wood to use. I often woodburn cutting boards made from maple because it's harder and denser than other light-colored woods and can withstand more from a knife. Maple has a dreamy low-grain surface and darkens slightly to show an ever-so-deeper hue when sealed. Of all the wood smoke I've smelled, I think maple smoke smells the best.

Oak

Oak is a harder/denser wood than the others shown here and it also has a somewhat finicky grain texture. But it's a beautiful wood often used in woodworking, so adding woodburned embellishments onto oak products is commonly done. I like the deeper color of oak wood for furniture and it does well with boldly burned designs. Oftentimes, the dips in the grain will need to be burned carefully, holding the heated tool above the same area for a longer time to create an even gradient.

Pine

Pine is the most prevalent wood in any wood supply store because it's the least expensive of all the woods you could buy to use. While pine can be an economical option and a great choice for many alternative woodcrafts, you must be more discerning when choosing the right piece of pine for woodburning. Not all pine products are created equal, but all pine will have some amount of resin in the wood. Depending on how the tree grew, how it was cut, and what part of the tree was used, pine can be an acceptable choice for pyrography projects. However, some pine products should be avoided altogether: those with large, visible resin pockets or tightly packed grain patterns. (Safety note: Pine smoke is harsh on the lungs and should never be inhaled without wearing a respirator and using proper ventilation in your work area.)

BASSWOOD

POPLAR

BIRCH

MAPLE

OAK

PINE

Pyrography Safety

Because woodburning involves the use of heat and fire—and thus generates smoke—there are certain measures you should take to ensure you stay safe while being creative. With these safety goals in mind, you can develop habits that will minimize risk and maximize your enjoyment of pyrography.

GETTING SET UP

Before you begin woodburning, you should create a designated workspace for you to use your tools. If you're woodburning in your home, make sure you set up an area in a room that can be sealed off from other areas of your home so you can control any smoke drift wafting outward from your work zone. Anywhere with a door that closes and at least one window for ventilation is ideal. Make sure you have a desk or tabletop free of clutter and large enough for you to keep your tools and projects separated.

You always want to woodburn with a desk or tabletop beneath you in case your hot tool slips off the edge of your project. If you attempt to woodburn while holding an object on your lap or balanced in your hand, your chances of getting accidentally burned are much greater. Always keep your workspace relatively clean and free of all flammable objects that could come into contact with your woodburning tools. Woodburning while seated is safer than standing and will give you more consistency and control in your artwork.

WHAT TO WEAR

Too-loose clothing with oversized sleeves can get in the way and snag or the sleeves could accidentally get singed. For that reason, I recommend wearing fitted clothing while woodburning, tying your hair out of your face if you have long hair, and rolling up your sleeves so they aren't in the way. Some people like to wear heat-resistant gloves or finger guards while they're woodburning. If your tool is becoming really hot while you're woodburning and it's burning your hand to hold it, try turning down the temperature or wearing gloves to add an extra layer of protection from the heat.

PROTECTING YOUR LUNGS

Using Fans and Filters

Ventilation is arguably the most important way to protect yourself from excessive smoke inhalation while woodburning. A fan blowing smoke away from you toward an opened window is a great way to ventilate your workspace. In the wintertime or in colder climates, this can be more tricky, but making sure your space is ventilated is of the utmost importance. In addition to window ventilation and fans, I use a desktop air filter called a Woodburning Buddy (shown at left). It sits next to my project on my desktop and sucks the smoke through a carbon filter immediately as it's generated, which really cuts down on the ambient smoke in the room.

Wearing a Mask

Because your face is so close to your artwork (and the origin of the smoke), it's also a great idea to wear protective gear over your nose and mouth to filter the air you're breathing. I recommend using a face mask or a respirator approved by the NIOSH (the National Institute for Occupational Safety and Health) because it will filter out the smallest kinds of particulates from the air. Over time, the amount of smoke you could potentially inhale while woodburning really adds up, and by implementing these simple safety precautions, you can save your lungs from unnecessary exposure. Despite great ventilation practices, your space might still become smoky with prolonged woodburning sessions, so it's important to be able to close the door, go to another space, and let the "dust settle" at times.

HAND PLACEMENT

When woodburning, you'll often stabilize your project with your nondominant hand and woodburn with your dominant hand. With particularly small projects, it's important to keep your fingers out of the way of the trajectory of your hot tool in case it slips by accident. It just takes a split second for the high temperatures of your pyrography pen to damage your skin. I should also note that I don't advise woodburning while under the influence of anything that could impair your ability to focus and be mindful of your safety.

Most seasoned pyrographers have been burned at least once by their tools. As with most occupational rites of passage, it's less a matter of "if" than "when." Try to be as careful as possible with your heated tool to help you avoid painful accidents.

TIPS FOR CREATING A SAFE WORKSPACE:

- Use proper ventilation.

- Seal off your workspace from other rooms.

- Wear the proper safety gear.

- Keep your workspace clean and free of flammable objects.

- Wear fitted clothing and roll up your sleeves.

- Always turn off your machine when not in use.

- Always burn on a desk or a tabletop—never on your lap.

Before Burning

Although you might be eager to jump right into woodburning, there are a few steps you should take to make sure your wood is properly prepared. Learn how to create a smooth surface and transfer designs to your burning projects by following the simple methods shown here.

PREPPING YOUR SURFACE

After you've selected the perfect materials for your project, you should take a moment to prepare your surface for burning by sanding it smooth. Although many prepared woods from craft stores will come pre-sanded, it's always a good idea to smooth any texture on the surface right before you transfer your design. Any little fray of wood grain or roughness has the potential to show through in your woodburning. Once your design is transferred or once you begin burning, the ideal time window to sand the area will come to an end, so starting with a smooth surface beforehand is the best way to go.

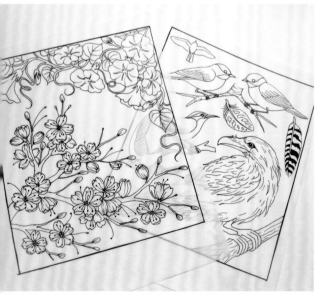

SELECTING & TRANSFERRING YOUR DESIGN

There can be many factors to weigh when choosing a design or template. Some considerations might include the size, shape, and species of the wood you'll be using, the subject matter you want to burn, and whether the wood has any unique features you want to emphasize or hide within your design. You can choose to transfer a pre-drawn design onto your wood before burning. The following pages describe three ways you can do this.

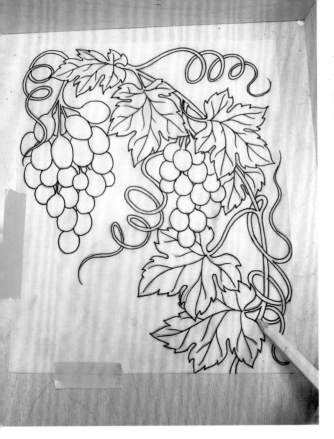

Tracing Method

This method will help you develop muscle memory and practice your drawing skills as you go. For this method, you'll only need a translucent piece of paper and a pencil.

1 Either use a printer to print out a design onto translucent paper or lay the translucent paper over the design and trace the lines onto the paper with your pencil.

2 Once you have a piece of paper with the design on one side, flip the paper over so your design is now face down and then trace the same design with your pencil on the opposite side of the paper. Make sure to use really bold lines, depositing plenty of graphite from your pencil as you're tracing on the back side. When you've completed this step, you should have a piece of paper with the design on the front and a mirror of the design on the back in pencil. Now you're ready to transfer this design onto your wood.

3 Secure your design onto the wood with tape, with the bold penciled lines on the back of the paper facing the wood and the original image facing upward. Use your pencil one last time to trace back over the image, using firm pressure to press the graphite from the back of the paper onto the wood. When you're finished tracing all the lines on the front of the paper, the graphite from the back of your paper should have transferred your image onto the wood. Once you lift the paper up from the wood, it will appear as if you had drawn the image onto the wood with pencil and the lines will be easy to erase if needed later on.

The grapevines design shown here was transferred onto this serving tray with the tracing method. Once the grapes were printed, the sheet was flipped and traced and then placed onto the wood and traced once again to transfer the image.

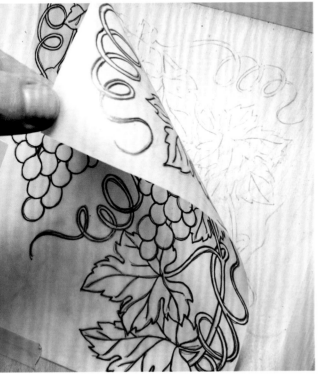

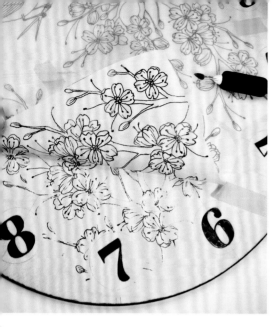

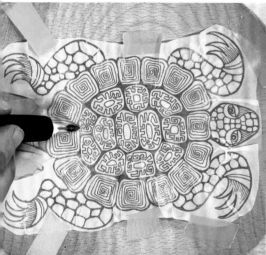

Heat Transfer Method

This method uses a laser printer, some paper, and a transfer shader tip.

1 Use a laser printer to print out onto either plain white paper or translucent paper the image you want to transfer. I prefer translucent paper so I can see through to the wood as I burn, but this method will work just fine with plain white opaque paper. This method won't work if you print your image with an inkjet printer because the heat will only transfer the toner from a laser printer and not regular ink from an inkjet.

2 Once you've printed out your image, you can cut it out if needed and use tape to secure it face down onto the wood.

3 Use the transfer shader tip to press evenly and glide your tool back and forth across the paper as if you were using an iron to press wrinkles from a shirt. If you don't have a transfer shader, you could substitute any flat-bottomed shading tool to achieve this same effect. I like to use higher heat for this process because the more heat you use, the faster your design will transfer. The heat from the tool travels through the paper and reliquifies the toner ink, which is then pressed against the wood to create a mirror image of the design onto the wood.

If you're unsure whether your image is transferring, try starting on one corner so you can lift up the paper and peek beneath it periodically to check the progress. Remember to methodically go over all the lines of your design. Once you lift the paper off, it's hard to put it back on exactly the same, so it's best to do a thorough job the first time. Taking your time with the design transfer will make the process of burning your design easier in the long run, especially if your design is at all intricate or technical. If toner smudges are visible after you're finished burning, you can use fine grit sandpaper or an X-Acto knife to scrape away the toner.

You can see how the cherry blossoms shown at top left were printed, cut out, taped down, and transferred using the heat transfer method onto a clock face. For trickier surfaces, such as the curved wooden bowl shown at left, the heat transfer method is a real winner. Start by taping down the middle of the design in the center of the space and then working outward toward the edges, folding as needed in areas that won't be affected much by the folding. When the paper is removed, the places that receive less heat might not transfer well, leaving patchy areas. This can happen, but do your best to apply enough heat to all the lines before removing the paper for the finest results.

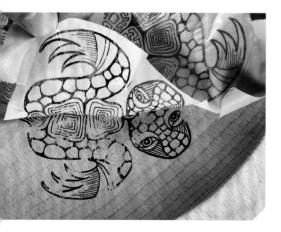

PyroPaper Method

This method uses PyroPaper only. Images can be drawn or printed onto it with any kind of ink before burning. Once your design is on the paper, secure it onto the wood with tape. For this method, you burn directly through the paper with your heated pyrography pen. The tip burns through the paper and into the wood as you trace the lines of the design. Pieces of the PyroPaper might break away as you go, so be mindful of that. I recommend tracing the lines with a sharp-edged tool to get crisp outlines. Once you've traced through the paper, you can remove the paper. You'll be left with a woodburned outline of your design on your wooden surface, which you can then fine-tune and add shading and details to. For a closer look at this method, see pages 34–35 to learn how PyroPaper is used to achieve sharp lettering on a wooden sign.

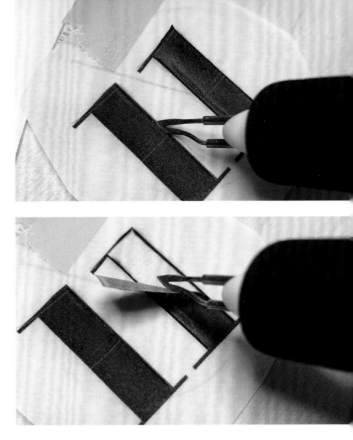

TIPS FOR CREATING YOUR OWN TEMPLATE

If you'd like to create your own template, there are a few ways to do it. First, you can draw your original design in black and white, scan it, and print it onto translucent paper. You can then use one of the transfer methods to transfer your design onto the wood. You could also draw your design directly onto the translucent paper before transferring. For letters and numbers, the best method is to type your template in a word-processing document and print it onto PyroPaper or another translucent paper before transferring.

For those of you who are confident in your drawing abilities and want to burn your own original drawings, you can either create your own template to use and reuse as shown on the previous pages or you can choose to draw directly onto the wood. If you draw directly onto the wood, make sure to use a pencil and press lightly so any extraneous pencil marks can be easily erased if needed. When erasing pencil lines on wood, you *must* use a white eraser, not a pink one. A white eraser will remove the pencil lines without any smudging whatsoever. A pink eraser will leave big pink smears in your wood that are very difficult to remove.

Once your design is properly transferred, you're ready to start burning!

Shading

Bring your woodburned art to life through shading! Using your shading tools to combine light, shadow, and texture, you can create realistic-looking art in a variety of styles to dramatically enhance your pyrography.

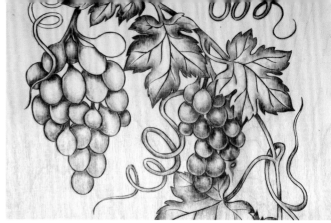

SHADING TOOLS

Numerous shading tools are available for woodburners and they generally fall into one of two categories: angled shaders and curved shaders. Angled shaders usually terminate in a triangular point and most have a flat bottom—sometimes with an additional angled bend. Some curved shaders will have a rounded, spoon-shaped bottom rather than a flat bottom. All shading tools can be used somewhat similarly, but some shading tools really shine at particular tasks. Angled shaders are best for fitting into tight spaces, creating bold contrasts and straight-ish lines, whereas curved shaders are better for seamless blending and subtle shading.

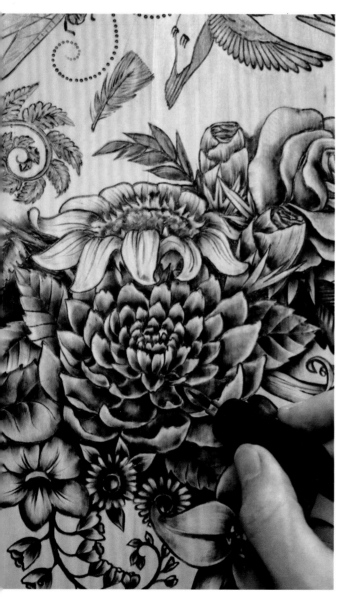

BASIC RULES FOR SHADING

- Choose the appropriately sized and shaped shading tool for your project.

- Always shade from the darkest area outward toward the lightest area, pulling your tool smoothly across the surface from dark to light.

- Build up your layers slowly on low heat to create the smoothest gradients.

- Utilize contrast to create depth and dimension in your composition.

- Shade with a specific light source in mind.

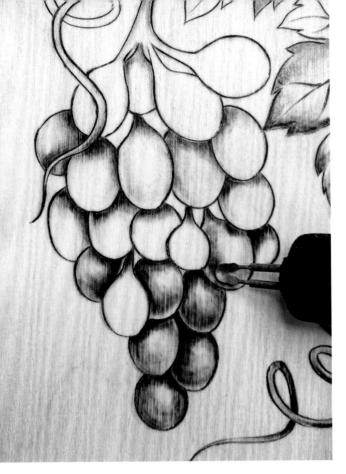

SHADING GRAPES

I used a spoon shader on low heat to render these grapes round and plump, using steady, circular motions. I created shadows beneath overhanging grapes and leaves to push some grapes into the background and coax others toward the foreground. With each grape, I imagined its shading by gauging its proximity to the other grapes and leaves and then envisioning where the light might or might not shine upon it. By shading a C-shaped shadow alongside the edges of each grape, the 3D curve began to emerge. With sunlight in mind, I left small portions of the grapes unshaded to create the effect that light is shining and reflecting on the grape skin. I also left the outer edges of each grape unshaded, giving them a bit of a glow, as they'd likely appear in real life.

When shading grapes, begin from the underside and work your way up. It also helps to first burn the areas that will be the darkest in order to map out the shadows and then work on detail shading from that point. Beginning by visualizing your darkest color (the dark shadows) and your lightest color (the natural unburned color of the wood) will give you a clear range of shading values you can work between when creating your art. With this gradient and a light source in mind, you can work much more effectively toward a cohesive shading strategy.

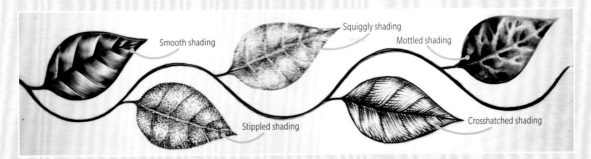

Smooth shading

Squiggly shading

Mottled shading

Stippled shading

Crosshatched shading

SHADING WITH TEXTURE

The main shading techniques emphasized on these pages are focused on creating smooth gradients and even shading. However, there are endless textures you could create with pyrographic tools to shade your artwork. For example, you can use a ball tip to create stippled shading with many small dots. With a curved knife, you can make crosshatching patterns and parallel lines to give different textural values to your art. You can use a writing tip to create squiggly patterns for a soft textured look. When shading with any tool, remember that the areas with denser and darker marks will tend to fade into the background and the areas with lighter, sparser markings will come forward in the design. Experiment with the various tools to find what works best for you and your personal style.

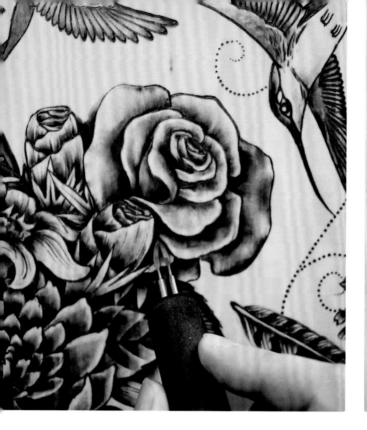

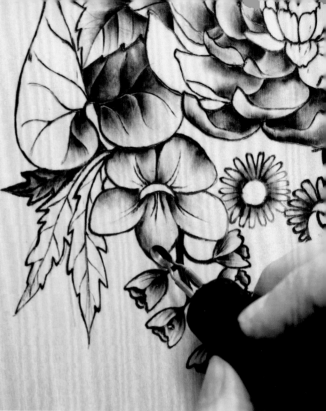

SHADING FLOWERS

When beginning to shade a flower, don't become overwhelmed by the flower in its wholeness. Split up each section into the smallest parts you can. Focus on one petal at a time, paying attention to its relationship to the other petals and leaves around it and shading accordingly. The pieces will eventually come together to form a unified image. For each petal, imagine where the darkest part will be, where there would be shadows from overlap, and where the light would hit. Flowers in all their glory are rarely perfect in symmetry or design, so using variation in your petal shape and shading will give it a realistic appeal you can fine-tune as you go.

I brought these flowers to life with an angled shader and a spoon shader. After I burned the outlines, I added the shading thoughtfully. An angled shader worked well in areas with sharp lines and small crevices. A spoon shader worked best in areas that were less defined but needed some billowy shape or a soft shadow. I shaded each flower in accordance with its placement in the design and against its background. For the flowers whose petals were shaded lightly, a dark background was the most fitting to help them pop. For the flowers and leaves that were shaded darker, a light background gave the contrast they needed to stand out.

The final result is an exciting flowerscape that balances shadow and light to guide the eyes around in interesting ways. Nothing is too overpowering and nothing disappears into the background either. This is always the goal with good shading: to highlight what needs to be highlighted without diminishing the rest of the composition. Creating focal points that aren't overstimulating and shadows that aren't too plain can be a fun challenge for an artist of any skill level.

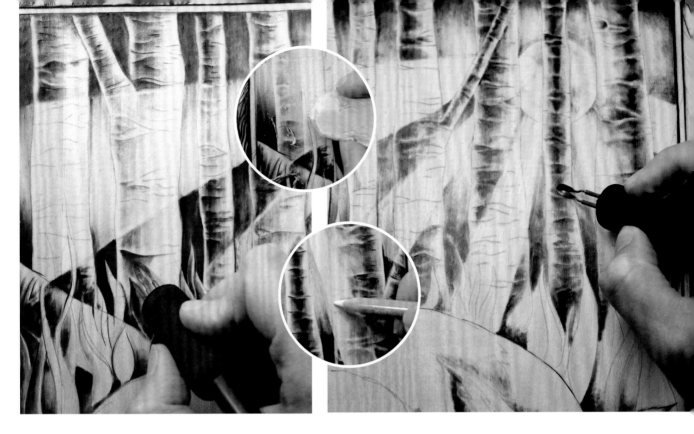

ADVANCED SHADING

Light sources are critical for any visual art form. I enhanced the shading for these birch trees by including a complex light source: moonlight filtering through the trees from behind. Using the birch tree template from page 117 and some basic adaptations with a ruler, I quickly created the starting point for this design.

As always, I began shading with the darkest areas in mind. I knew the light beams would be the lightest, so I left those alone until the end. The sky nearest to the moon would be the brightest, so I shaded the darker parts of the sky from the outer edges inward toward the moon.

With rounded objects, such as these tree trunks, the light "hugs" around the curve from both sides no matter where it's coming from, so I wanted to make sure to give each edge of the trees a proper amount of moonlit silhouette. For each tree, its angle to the light source differs, so the shadow upon the tree bark must also naturally change. The tree directly in

front of the moon has its darkest shadow in the very center because it's directly opposite the light source. The trees farther to the side will catch more moonlight on the side facing the moon and thus the shadow shifts over toward the opposite side where the light won't reach.

I shaded the areas within the light beams in the same way as the rest of the image—just in a lighter shade to keep the clarity of the light beams clearly flowing across the page. I enhanced the texture of the bark by slightly digging the edge of an angled shader into the wood to emphasize the crevices in the bark at random intervals.

Once I had sufficiently tweaked the shading, I made sure to erase all the pencil lines and I added highlights with a white colored pencil to sharpen the image, as show in the circles above. White highlights can be a perfect way to get your shading to appear crisp without distracting from the natural look of the woodburning.

Solid Black

Incorporating the bold look of solid black into your designs is something you can achieve with the use of the right woodburning tool and the right temperature—and a little bit of perseverance to see this technique through.

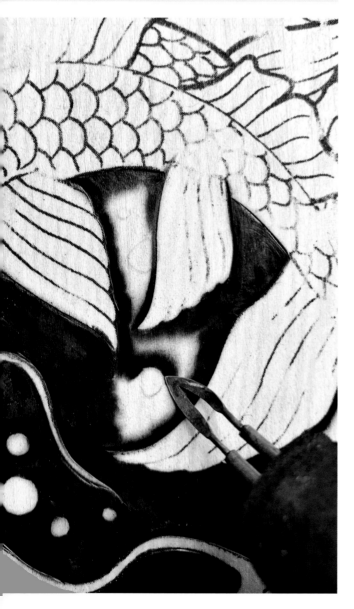

THE BASIC HOW-TOS

The main ingredients of creating solid black are heat plus time. To get an even, solid black, you'll want to use a shading tip with a flat bottom. The larger the surface area your tip covers, the less time it will take overall to get your black background finished. However, if you have lots of little details to work around, choose a tip that will fit into the spaces you need it to and go slower in those areas. Making sure the burn goes where you want it to go is more important than burning quickly.

Small back-and-forth motions that go with the grain or small circular motions will give the best results. Start somewhere on an edge and work your way across the space methodically. I like to first outline all the edges where the black is going to go and then I work on filling in the space between them, as seen in the photo at left. Breaking up the work into sections will help you see progress as you go and will make the job less tedious. Put on some music and get into the groove of the small, sweeping motions and you'll have your solid black in no time.

GETTING STARTED

Depending on the kind of wood you have, you should adjust your heat to the highest setting that won't scorch your wood. Different species of wood can handle more or less heat, so you should begin on low heat and work your way up to the maximum heat that still gives you a smooth, glossy layer of carbon. If your tool is making the wood burn so quickly that you're hearing hissing sounds and your tool is sinking deeply into the surface of the wood, you have too much heat and should turn down the dial.

If you're still having sinking problems, you might be pressing too hard. Your tool should be pressed gently onto the wood and the heat from the tool should be doing the work for you as it glides across the surface. If you're burning the same spot for a while and the solid black is turning out more of a light brown burnt color, you likely need more heat. If the area around your tool is turning yellow as your tool passes from the ambient heat given off by your tool and you want to avoid this overburned look, turn down the heat and go slower.

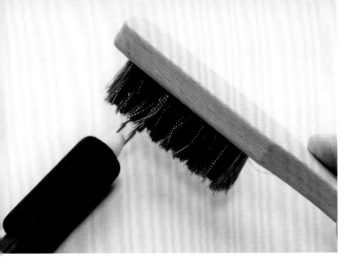

KEEPING YOUR TOOL CLEAN

Your tool will build up carbon during the process of creating solid black and it will need to be cleaned and scraped frequently. You can scrape your tool during use without turning it off as long as you have a metal scraping tool. (See page 15 for recommended tip scrapers.) If you allow too much carbon to build up on your tool, your burning will take longer and will be less smooth to the touch. Keeping your tool clean from buildup is key in getting the smooth, glossy black that makes this technique so popular for a sleek, polished look.

TORCHES

You can use a torch to create a smooth, solid black much faster than a regular pyrography pen. However, a torch isn't a precision instrument and you'll need to decide whether it's a good fit for your project. Torches are best used in large, wide areas without a lot of details or light areas to avoid. If you burn a portrait and want to create a solid black background, you could use a torch to darken the areas all around the head, but you don't want to use a torch too close to the edge of your portrait. Leaving yourself a perimeter or buffer zone to be darkened with a shading tip is a smart way to keep the dark, crisp edges dialed in and then you can use a torch to finish the outer areas, thus reducing your overall time commitment.

The same principles apply to using a torch to burn solid black: heat plus time. When using a torch, you might enjoy varying the distance between the end of a torch and the surface of your artwork. The closer it is, the darker and faster it will burn. The farther away, the lighter it will burn. As always, start on a lower heat setting and work in circular motions one section at a time. Most torches will come with a setting to increase or decrease the output of the flame so you can adjust the effect of a torch on your wood by varying the temperature output, the distance between a torch and your work surface, and the length of time you hover it over each spot.

CARBON LIFT

A common issue that can arise when creating solid black is that carbon lift can happen at the sealing stage. Carbon lift is when tiny loose particles of wood that have been burned and turned into fine carbon dust break away from the surface of the wood and "float" upward, suspended above the surface of your artwork. This allows light to enter the space where the particles had previously been, which might lighten the black in areas. To ensure your solid black remains completely black, you can rub a white eraser vigorously over the entire woodburning to remove any loose carbon from your surface, thus revealing and cleaning areas susceptible to carbon lift.

NOTE: A white eraser is critical for dealing with carbon lift. Do **not** try this with a pink eraser or your artwork will be covered in pink smudges. You could also use a damp cloth or a paper towel, rubbing it somewhat firmly across the surface. If any areas appear to be lighter than you intended, simply go back over them with your hot shading tool until they're completely black again. Taking the time to do touchups like this can make the difference between your work looking splotchy and rushed or looking sharp and professional.

Linework

Precision is essential when it comes to linework. Burning clean lines can really enhance the quality of your artwork. Set yourself up for success by choosing the right tool and using it properly.

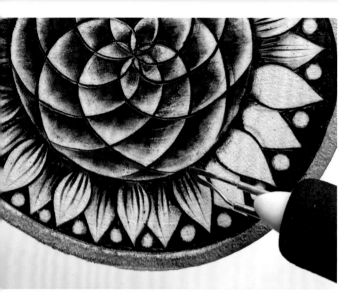

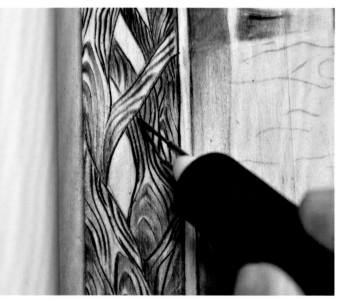

CURVY LINEWORK

For curvy linework, such as for henna-inspired designs, a writing tip is the best choice. Made for gliding smoothly over the wood, this tool navigates around curves with ease. The line created by a writing tip is usually a little thicker and bolder than a knife or a straight-edged tool, so bold designs also favor this tip. When you're trying to create a smooth line, high heat will help you burn through the wood at an even rate. Retracing the same lines several times will create an even smoother, darker outline. A writing tip is aptly named because it will give you a feeling as if you're writing or drawing with a pencil—free-flowing and unrestrictive.

STRAIGHT LINES & SHARP ANGLES

When it's of the utmost importance to have crisp, fine linework, always gravitate toward a straight-edged tool. For example, you can use a curved knife, a straight knife (also known as a skew), or the edge of an angled shader. The sharp edge will give you the precision you need. By adjusting the heat setting, you can control how deeply your edge sinks into the wood. The more heat and pressure you use, the deeper your lines will be.

A curved knife is my favorite tool for precise linework. Not only does it cut through the surface of the wood with ease, but it's also perfect for creating flowing lines, such as the wood grain pattern seen in the photo at bottom left. The curve on the underside of the knife allows you to create tapered lines or navigate some curves and undulations with one stroke. Imagine the sharp edge of your tool is like the rudder of a boat. By gently twisting your tool to the left or to the right as you burn, you can steer your lines without picking up the tool from the wood. In this way, the tool creates a sharp and defined line—with you as the guide. I like to begin at the top of the artwork and pull downward with each stroke for the best control. (Orient your artwork accordingly so you can pull your strokes downward.)

NOTE: I recommend not pressing too firmly with your tools. Pressing too hard with your tool can eventually bend your tool out of its proper shape. If you're pressing hard to get a darker or deeper line, simply turning up the heat or burning slower will give you the result you desire.

Stippling

Stippling is woodburned pointillism: combining many individual dots to create one image. Stippling gives added texture and visual interest you can only achieve with certain tool shapes and methods.

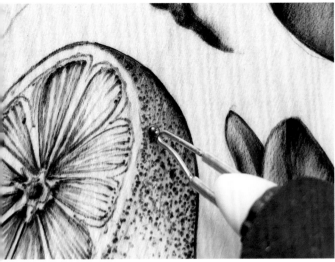

GETTING TO THE POINT

Any ball tip is the best tool for creating stippling on your artwork. The larger the ball on the end of your tool, the larger your dots will be. The longer you hold your tool to the wood and the hotter the heat setting you're using, the darker and deeper your dots will be. The combination of pressure, speed, heat, density of dots, and ball size will give you the variations you need to create the effect you desire.

When stippling, hold your pen upright (perpendicular to the surface you're working on) and use up and down motions, moving ever so slightly in different directions after each dot to vary your dot placement. Randomizing your dots is important so you don't create lines of several dots. If you hold a ball tip at an angle when you touch it to the wood, you might create an oval dot instead of a round dot. The uniformity of dots isn't always equally important, but if your dots are turning into ovals and they're leaning the same direction, this can be distracting to the eye and create a slanted effect to your artwork. Always begin by placing dots in areas that are going to be the darkest and work your way outward toward areas that will be lightest. To create darker areas, you must make more dots in an area with less space between them. To create lighter areas, spread your dots out farther and farther. For darker areas, you might want to use a higher heat setting and then turn down the heat as you work your way outward toward a lighter spot.

Stippling can be used to create gradients on finicky materials, such as gourds. With their light density and oftentimes bumpy or uneven outer shell, gourds can be difficult to shade evenly with a regular flat shading tool. Stippling allows you to create the illusion of a smooth gradient even where there are obstacles on the surface you're working with. The alluring effect given by stippling is a visual and tactile one because each burned impression on the gourd surface can be felt even after it's sealed. Plus, the finished product reflects light in an artful way. I used a large ball tip to create the black decorative areas on the gourd and I used a smaller ball tip for the leaves and flowers on the rest of the design.

Stippling is especially fitting for a lemon skin, as shown in the photo at left. For dimply subjects like this, the dots beautifully recreate the natural texture of the fruit.

Lettering

Creating beautiful lettering on your woodburning projects can be a challenge even for seasoned pyrographers, but it doesn't have to be. Use these tips and tricks to help you create perfect letters every time.

PRINTING YOUR TEMPLATE

For those of you who are confident with hand lettering, you can draw your letters with a pencil directly onto the wood. But for the rest of us, using a word-processing program and a printer will be the best choice. To create a template for your project, such as the wooden sign shown in the photo at left, first decide what you want it to say and how large the characters need to be to fill the space. Use whatever word-processing program you have on your computer to create a template. You can play around with sizing, different fonts, and page orientation until it's just how you want it. Printing it out onto PyroPaper or another translucent paper will help you transfer it precisely. Any of the transfer methods from pages 23–25 will work to get your template onto your wood, but here, I'll focus on the PyroPaper method because it involves fewer steps and is more likely to result in perfect letters. Tape the template to the wood and you're ready to begin.

HOW TO BEGIN THE OUTLINE

The special thing about the PyroPaper method is you can actually burn directly through the paper itself. For other transfer methods, you might find yourself tracing over your image several times before you begin burning. When using PyroPaper, you save yourself a lot of time and extra steps by burning directly through the paper with your hot tool.

When lettering on wood, having a crisp outline is important for getting your letters to be uniform and flawless. You don't want scorching or uneven edges to detract from the words on your sign. Making a beautiful and easily legible sign is a matter of taking your time and not rushing through the steps. Using a sharp-edged tool, such as the small curved knife, trace the straight edges of the letters on low heat to prevent any scorching/overburn. Go slowly and be deliberate about your tracing to create a crisp outline on the wood surface beneath the PyroPaper. Once you've created the outlines, you can remove the PyroPaper and fill in the rest of the letters.

FILLING IN YOUR OUTLINES

Once your letters are outlined, you must choose a tool to fill in the space. Here, I chose a writing tip to color in the areas. I picked this tip because it's compact enough to fit into the small spaces of the letters and I have a lot of control over where the burn will go. Had I chosen an angled shader, which has a much larger surface area, I would have worried about overburn or accidentally burning outside the lines. Starting from the center of the letter, I began to fill in the spaces and I worked carefully outward toward the edges. In this methodical way, I filled in all the letters until they were solidly burned.

I used the same step-by-step method to create the numbers for the clock project. I printed the numbers onto PyroPaper, cut them out, and placed them in their proper places. I transferred them to the wood, as shown in these photos, and then I filled them in.

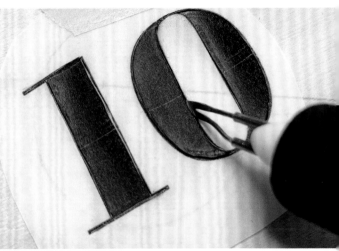

HELPFUL TIPS

The most important things to remember while lettering are to use low heat, go slowly, always create crisp edges, and fill in your letters from the inside out. If you're creating an artwork with very small letters, using a font that's not too fancy will create the best effect. Using a writing tip on low heat will also help you keep true to the shape and thickness of the letters. The larger your letters, the more fancy you can be with your font. Always make sure your letters are level and straight before taping your template to the wood so your sign doesn't end up appearing tilted.

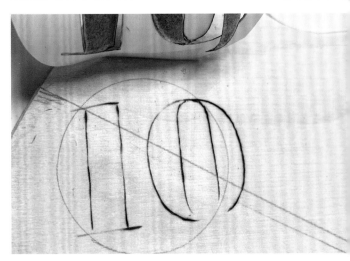

Scales

Whether you want to burn mermaids, fish, snakes, dragons, or other kinds of scaly creatures, there are some simple woodburning techniques you can use to help your scales come alive.

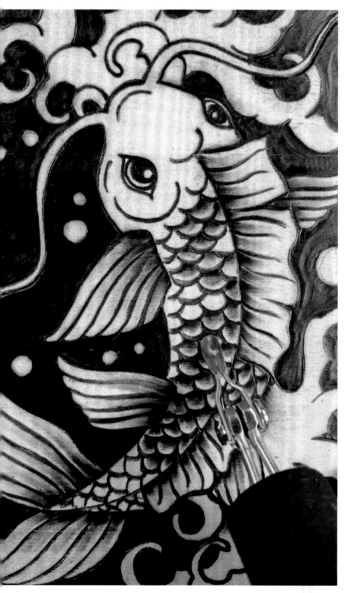

THE BASICS

Scales are basically just a bunch of overlapping shapes— typically arranged in a bricklaying or shingle pattern— where the center of one scale partially covers the seam between the two scales below it. Different creatures have slightly different scale shapes, but generally, the scales terminate in a rounded or oval shape. The basic scale shape can be drawn easily with a pencil and then burned and shaded by hand. To begin, you draw a row of U-shaped semicircles. The row beneath the top row begins at the center of the first scale to create the bricklaying pattern and begins and ends at the center of the adjacent scale. This pattern repeats to take up the space needed. Scales can be smaller or larger or you can draw other natural variations into your scales if you're drawing by hand.

BASIC SCALE SHADING

The most important thing to remember when shading scales is to always shade from beneath the scale above and toward the outer edge of the scale below. Regardless of the direction your scales are facing on the wood, the scale above is always the one overlapping the scale below. The gradient should generally be dark to light—from the innermost part of the scale to the outer. This creates an optical illusion effect of the scales coming forward from underneath the scales above them and gives a 3D look to your artwork. Watch as the scales on this koi fish go from flat to dimensional with this simple shading method. A spoon shader is a great choice for shading scales because it's curved and won't create any straight lines on your curvy scales. Because these scales were so small, a smooth rocking motion was enough to shade each one with a spoon shader, working from top to bottom.

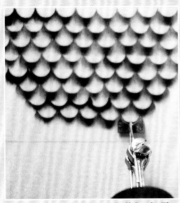

Full Scale Tip

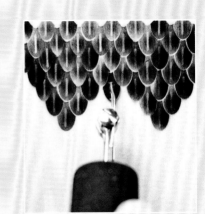

Realistic Keeled Scale Tip

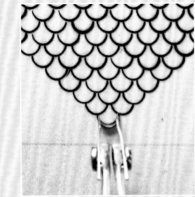

Sharp Outline Scale Tip

Realistic Full Scale Tip

SCALE TIPS

You can achieve any effect with a regular burner, but if you value efficiency over the tedium of doing it yourself, these handy scale tips can help you quickly create a uniform and beautiful pattern. I used four different scale tips on this snake to illustrate the difference in their effects and I did the scales on the last portion of the snake's tail freehand with a writing tip. This shows how each scale tip can be used to create a uniform scale effect and how hand-drawn scales differ from those drawn with scale tips.

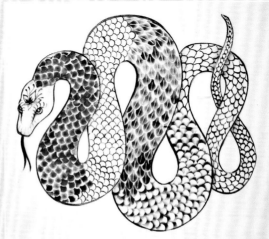

Feathers

Burning feathers is a great way to develop your comfort with fine linework and enhance your muscle memory to create flowing silhouettes. These pages show the process for burning perfect feathers every time.

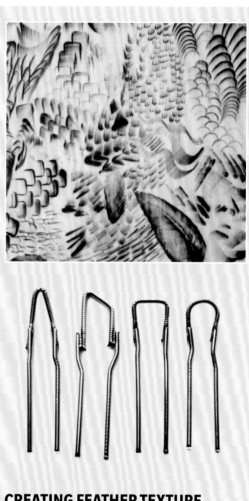

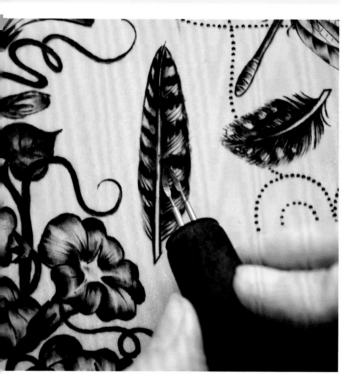

ADDING PATTERNS TO FEATHERS

Slightly leveling up the complexity on your feathers is simple. Build upon the techniques shown on page 39 by laying out the pattern you want you use. If you want broad, dark stripes, add this coloring into the feather with a shading tool after the linework is finished. If you want to have light-colored dots in your feathers, draw those areas with pencil before you begin burning and then avoid burning into those spots. You can use light shading to further emphasize the contrast between your dots and the rest of the feather.

CREATING FEATHER TEXTURE WITH FEATHER FORMERS

Feather formers are a series of pyrography tips you can use to create feathery textures when woodburning birds. They're best used to create small textures in places where feathers are less defined, such as chest feathers, downy feathers, or underwing areas. The feather former tips feature a coiled metal wire that creates multiple parallel lines with each stroke. Each tip is shaped differently to give you a range of capabilities for creating layered looks. In the top photo, you can see how the tips have been used to create all sorts of interesting shapes and textures.

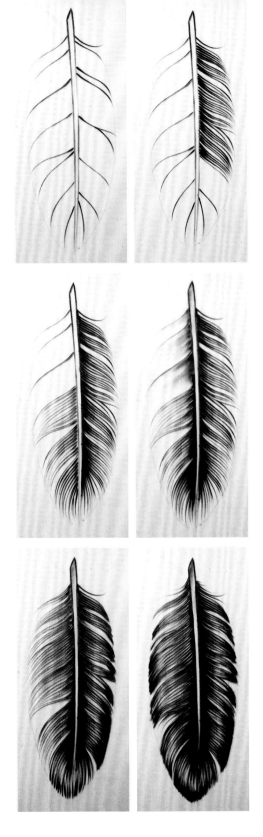

CREATING FULLER FEATHERS

- **Creating the basic shape.** With a pencil, draw the basic starting form for your feather. Start by drawing the center shaft. This should be a tapered line that gets smaller near the end of the feather. The center shaft can be stick-straight or it can curve to one side or the other. Wild feathers exhibit all kinds of variations, so don't worry about it needing to be perfect. Next, draw the outer edge shape of your feather. This is where you can decide whether you want to have a long, skinny feather; a feather with a pointy, square, or rounded tip; or a wide, oval-shaped feather. Once you make your basic outline, add a few guidelines to show the direction of the feather strands. The guidelines should come outward from the center shaft toward the outer edge at a slight downward angle.

- **Starting to burn.** Once you've drawn all your pencil lines, you can begin to burn your feather. Using a sharp-edged tool, such as a curved knife or the edge of an angled shader, you can begin burning the outline of the center feather shaft. Make sure your lines are crisp. After burning the center shaft, begin creating the feathery fronds by making flowing strokes outward from the center shaft toward the outer edge of the feather, using your pencil guidelines to help you stay somewhat uniform in your angles. Most of the feather strands should be parallel to each other, but it gives a more realistic and interesting look if you change up your feather strands slightly every so often. Creating little chunks of strands that curve differently or areas that create notches or openings in the feather mimics what actually occurs in nature.

- **Adding some shading.** As your feather starts to take shape, you can begin to add some shading details to help it appear more dimensional. Using an angled shader, shade outwardly from both edges of the center shaft to create a strong contrast.

- **Finishing touches.** Once you've completed all the lines on your feather, you can add the finishing shading touches to complete the effect. Add some definition to the outer edge of your feather by creating some lines from the outer edge that fade inward toward the center shaft. With the shading radiating out from the center and also coming back in from the edges, the feather strands have the appearance of being slightly rounded. This creates a bold feather design that stands out. If you want your feather to be lighter and wispier, you can forego the outer edge shading and simply shade lightly along the inner shaft of your feather.

Fur

Burning realistic fur is something many beginning pyrographers want to learn. Alternating between a sharp-edged tool and a soft shading tool allows you to create the right combination of texture and shading.

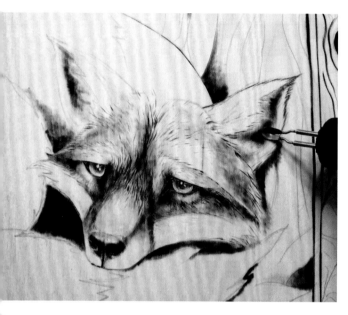

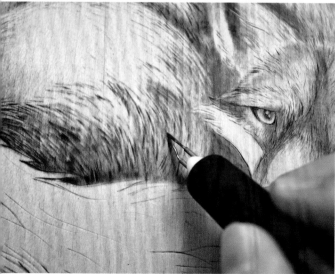

AVOID HARSH OUTLINES

While there might be some areas in your realistic woodburning where hard contrast does naturally exist, when it comes to burning furry animals, outlines are the exception rather than the rule. I prefer to softly blend the outer edges of the fur into the background to create a realistic look to the animal. If darker contrast is needed, you can always add that in layers of heat as you go. I like to create the general outline of the animal in pencil with light strokes to be as minimal as possible. Being able to easily erase the pencil lines you create will go a long way toward helping you create the realistic effect of fur, especially in light or wispy areas.

MAP OUT THE SHADOWS

This is where a spoon shader really shines. Set a good foundation for your detailed fur strokes by first mapping out the areas of light and shadow to start to create the 3D look. Squint your eyes and look at your reference photo from a distance. Try to just see the basic shapes of dark and light. Building on your light pencil sketch, you should be able to overlay this mental image of where the shadows will go. For this fox, the darkest areas are between and around the eyes, inside the ears, and where the tail and haunches meet as well as the underbelly. Work in layers of shadow in these darkest areas. You can also map out the shadows around your animal if you intend to create a background. You can always come back to these shadow areas and make them darker and more defined as you go, so don't worry about completing this step before moving on to the actual fur texture. In fact, I recommend alternating between these two methods periodically to adjust and layer the fur.

WORK FROM THE INSIDE OUT

As with any detailed project, I recommend beginning with the darkest areas and working toward the lightest areas. For many animals, this means working from the inner portion of the body and outward toward the extremities or from highly textured areas to simpler, smoother areas.

For the face, I always begin with the area around the eyes and work outward toward the edges of the face. It just so happens that the fur on an animal's face usually moves away from the eyes in several directions, so this is a natural starting place for mapping out the direction of your fur strokes.

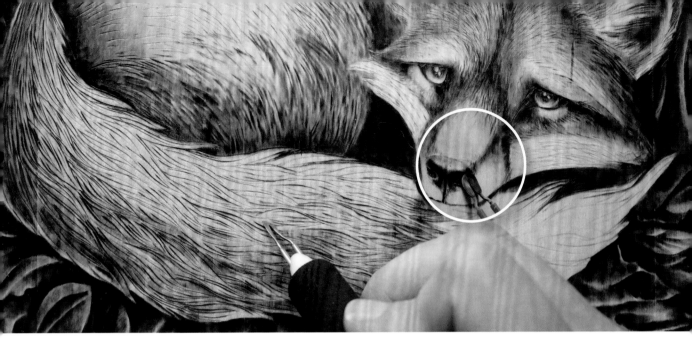

FOLLOW THE DIRECTION OF THE FUR

Always pay attention to the direction of the fur. If you're using a reference photo of a real animal to create your artwork, take a close look at the fur and notice the direction in which the hairs are pointing. Ask yourself these questions to really gain an understanding of the fur you're creating: How does the fur move away from the eyes and around the face? Is it arcing over the forehead? If so, how tight is the arc? Are there areas where all the fur comes together or areas where the fur separates from itself? Are there denser and therefore darker areas? Are there wispier and therefore lighter areas? Is the fur all one color or does it have a pattern? Are there shorter hairs in one area and longer hairs in another? Short hairs mean you have to use short strokes and long hairs mean you have to use long strokes following the fur's direction. Those little details can make all the difference in creating a lifelike piece of art.

I used a curved knife to create the fur strokes on the fox, supplemented by the edge of an angled shader. Because the face has shorter hair and more subtle details, I mapped out all the fur direction with a curved knife to create a visual guide for how to allow my strokes to travel across the fox's face and body. This step was helpful when it came time to add to the density of fur strokes because then I had a good understanding of where my strokes were going and I could follow my own guidelines.

Combined with the shadow mapping you do with a spoon shader, this technique of using a curved knife to burn the fur strokes is all you really need to make your fur burning come to life. A spoon shader was also used to create the shading on the fox's nose (circled above).

VARY YOUR STROKES

No animal in nature has fur that's all lined up in perfect parallel strands, so your woodburning shouldn't either. And thank goodness for this because burning fur would be much harder if every hair had to be perfect. Embrace the opportunity to let imperfection work for you. When you're using a sharp-edged tool to create fur, vary your strokes! This means move your hand slightly differently with each stroke to create just a touch of variation so your fur looks natural. You're reaching for a balance between varying your fur strokes and keeping with the intended direction of the fur. This can take practice, but with time, it will become second nature and your strokes will easily fall into a rhythm of organized randomness.

Remember that you can always add more details, so continue with this back-and-forth process of honing your artwork until it looks just how you want it to. With some practice, you'll find burning fur is much simpler than it seems. Gaining confidence and experience is half the journey!

Adding Color

Whether you use vibrant hues or subtly washed tones, your artwork becomes more dimensional with color. Learning how to add color to your projects gives you endless opportunities for variety and experimentation.

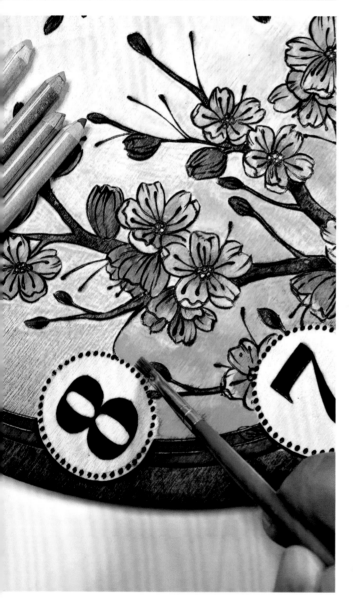

BEFORE ADDING COLOR

You'll want to make sure you've completed all your burning before you add any color to your artwork. Woodburning over color or stain isn't recommended because of the potentially harmful particles the smoke might produce. You'll also want to add your color before sealing. And it's a great idea to make sure any pencil lines have been erased before adding color because you can't erase them with color on top of them and they might show through.

Beginning with a clean, prepared, fully burned surface will get you off to a great start when you begin coloring your project. If you intend to use any liquid colors, such as paint or ink, use a palette or a small dish as a landing place for your colors. This will enable you to easily blend them or dilute them with water.

WATERCOLOR PENCILS

Watercolor pencils look just like regular colored pencils, but they come with an exciting added capability: The pigments in watercolor pencils are water-soluble, giving you the ability to masterfully blend your colors on your wooden surface. My favorite reason to use watercolor pencils is they allow you the control you need to blend colors precisely in small areas while giving you the freedom to take your time and get it just right. There's no reason to rush and they're quite forgiving. There are two ways to use your watercolor pencils: the dry method and the wet method.

The Dry Method

With this method, you color with the watercolor pencils directly onto the wood while they're dry—the same as if you were using regular colored pencils. When you've layered all your colors just how you want them, you simply wet a clean paintbrush with water and gently paint over the colored areas to dissolve and liquefy the color. In this way, you can blend the colors how you like them. After drying, if you rewet the surface, the watercolor pigments will dissolve and move around somewhat. You should try to make sure you get the color to dry how you want it at first to avoid any kind of smudging or uneven coloration if you aren't going for that effect in your artwork. If you're not getting a deep enough color or if your colors haven't blended seamlessly, keep the area damp and continue blending and layering colors until you're happy with the coloring.

The Wet Method

With this method, you take the sharpened end of your watercolor pencil and dip it into a cup of clean water—just as you would with a paintbrush for the dry method. When the colored tip of your pencil gets wet, the pigments will immediately begin to dissolve and loosen. You only need to dip the tip of your colored pencil for a few seconds before it's ready. Using gentle pressure, apply the color directly to the surface in the same way you'd normally color with a pencil. The color should automatically come off the pencil in bright hues right where you drew with it.

While the wet method produces a bold, bright, and fully saturated color from the get-go—but with less control—the dry method allows you to control how much pigment you deposit onto your wood and allows you to build your colors in layers and blend them once you're ready. For this reason, I most often choose to use the dry method. If you do choose to use the wet method, it's best to do it in larger areas without a lot of little details to work around. And because the watercolor pencil core will soften with water, the wet method will use more material from your pencil and you might need to sharpen it more frequently. Always make sure your watercolor pencils are fully dried before you put them away.

Whether you use the dry method or the wet method, you can always take a damp paintbrush to your art (ideally while it's still wet) and blend the colors however you like. The good thing about watercolor pencils is you can layer them and redissolve them with water as many times as you need to get the look just right.

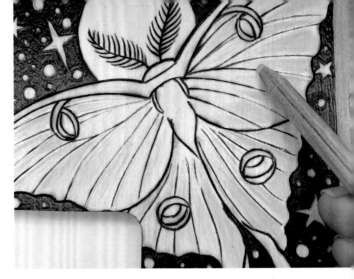

NOTE: When using water on your wood to add color, let your wood dry completely before sealing. Moisture can soak deep into the wood's pores and the wood might take time to dry out. A good rule of thumb is to wait at least 24 hours after you're finished painting, staining, or coloring your wood to apply any kind of sealer. In the meantime, make sure your project is able to dry out in a low-humidity room protected from rain and excessive condensation.

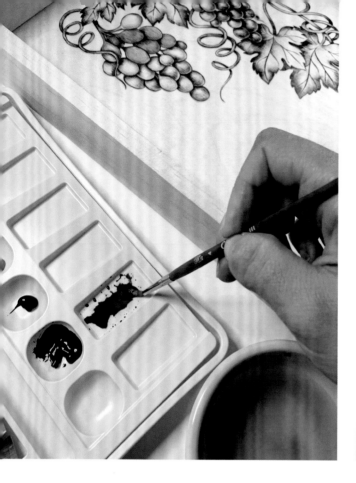

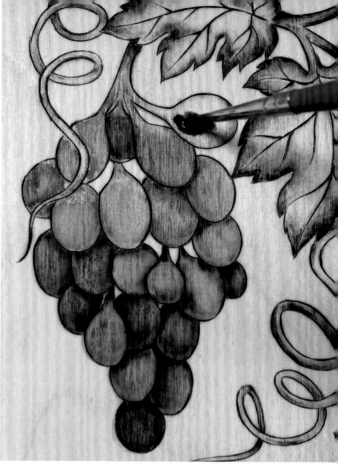

WATERCOLOR PAINTS

Being one of the first art supplies introduced to children, watercolor paints are a staple among art lovers everywhere. I love that they can be used on wood—and with such ease and beauty. Whether you use dry watercolor palettes or wet concentrated watercolor paint from a tube, the process is simple and straightforward.

Using a clean, wet paintbrush, blend your colors on a painting palette or in a small dish. Dilute your colors with as much water as you like to achieve either a subtle or bold hue and apply the paint directly to the wood with your paintbrush. I find it's better to use a small paintbrush or one with a stiff, angled tip so I can be really precise with where the paint goes. A stiff-bristled paintbrush tip will also allow you to gently scrape away any excessive paint you don't want to linger on your surface. Any pooling of excess paint on your artwork could create a splotchy effect or create dark spots where you might not want them.

If you're going for a subtle look, wetting the surface of your wood with plain water before applying the watercolor paint will help the immediate blending process to occur seamlessly. This is similar to the process often used by watercolor artists on paper. When using watercolor paint, it's important to not use a water-based sealer on top of your work because it can reactivate and dissolve the color, causing your coloring to bleed. An oil-based sealer is recommended over watercolor paints after the wood has been given ample time to dry.

WOOD STAIN

Wood stains come in a variety of natural shades—from yellow to red to brown—and you can find craft-quality wood stain in almost any hobby store. I enjoy using brush-on wood stains to accent my woodburning because of the earthy, warm tones and depths they create without drawing attention away from the actual burned art. Wood stain is the best choice when you're wanting a natural, woodburned result with just a touch of something extra. I usually choose a stain based on a wood tone I like, such as oak (usually a medium brown) or mahogany (typically a reddish brown).

When used as a background, wood stain will allow the foreground of your artwork to really pop. To use wood stain on your artwork, simply dip a clean paintbrush into the wood stain and paint it directly onto the area you're wanting to darken. You can use water to blend the wood stain to create a gradient or wet the surface of the wood prior to applying the wood stain if you want to have a lighter, more blendable application. Multiple coats of wood stain will consecutively darken the tone of the wood while still allowing the natural grain patterns of the wood to show through. Pay attention to how the stain looks as you're applying it—the color it is when wet is how it will look when it's sealed. Sometimes, when wood is dry, the color and the true hue of the wood are hidden or muted, but then with a layer of sealer, that saturation of color comes back.

With the decorative bowl shown at right, you can see how I applied the wood stain to the background behind the turtle design to help the turtle stand out. I used water to help move the wood stain around, create a darker stain around the edge of the bowl, and fade down to the bottom of the bowl. I applied more applications of stain near the top edge and I blended the excess stain downward until I got the look I was hoping for. While I was painting, the wood stain color appeared nice and dark. As it dried, the color seemed to fade out slightly and become uneven, but after a coat of sealer, that color came back to its proper vibrancy—and it will stay that way. Sometimes, you have to trust in the process and just go for it!

NOTE: If you're considering using colors on any functional object, such as a kitchen utensil, please remember that color of any kind will render your object unsafe to eat with. No bowls, spoons, rolling pins, or cutting boards can have color on them and still be used for actual food. But they can still be gorgeous decor items and objects for display!

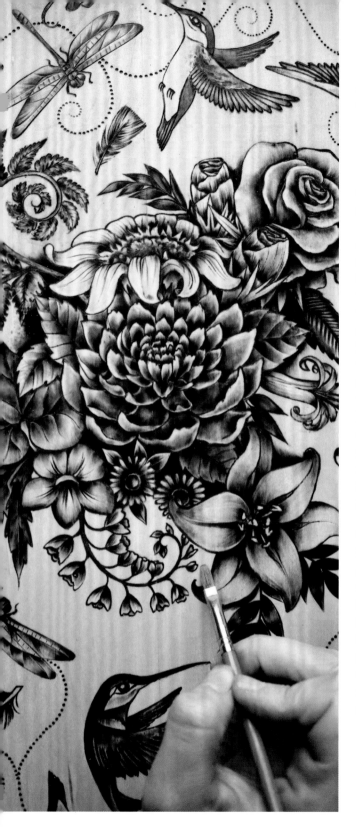

INDIA INK

Of all the color tools I've used, ink is my preferred choice for its vibrancy and quality. Wood absolutely loves ink—its bright and bold colors give a permanent result that really soaks into the pores of the wood, creating a durable and lasting bond. Various kinds of inks are available, including alcohol ink and acrylic ink, but here, I'll focus on the merits of India ink. India inks are transparent, so they won't cover up your woodburned details, and they form a waterproof, lightfast coating when dried.

Applying India ink is fairly simple and follows many of the same rules as the other coloring methods. You'll want to use a paintbrush to apply the ink. Less is more when it comes to these richly pigmented inks. Because of this, you might want to dilute a couple drops of ink with a small bit of water to create a lighter color and work your way up. If layered, the inks will blend together and create darker values while still remaining transparent. India inks dry quickly and are permanent when dried, so you won't be able to wash, blend, or otherwise move the color once it's where it is. This is generally a great thing; however, if you happen to spill or drip India ink into a spot you didn't intend for it to go, there's no erasing it. You should keep your ink on a separate surface away from your wooden artwork for this reason. India ink soaks deep into the wood pores and is virtually impossible to remove or erase if it bleeds or spills, so take the utmost care when you're coloring with it.

When layering inks, you can layer two or more colors while they're still wet, which will result in a blending of the colors, or you can layer fresh wet ink on top of dried ink. The wet ink won't affect or blend with the dried ink. This is especially useful in the case of flowers that have multiple colors running through them or any number of other colorful applications. White and black India inks are opaque, so if you blend white or black with any other color, you're turning the transparent color into an opaque color, which means you'll have to be more careful to not cover up your woodburned details when applying that particular color.

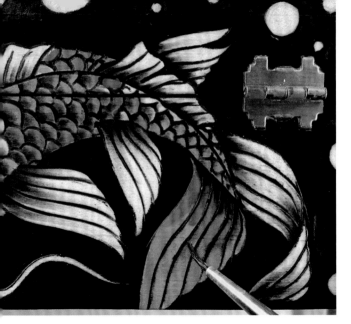
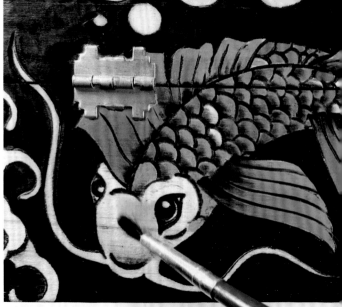

COLOR BLEEDING & OUTLINES

When adding color to a woodburning project, remember that wood is its own unique material, which will soak up colors, bleed colors, and generally allow colors to behave in ways that paper doesn't. Each piece of wood has its own behavior, grain pattern, and porosity, so some experimentation might be needed. The best way to ensure your colors won't bleed is to always color "inside the lines"—meaning that if you want to contain colors in certain areas, having a woodburned outline in the way will create a barrier for your color so it won't bleed through the grain and into areas you don't want it to be.

An outline can be any woodburned area that's deep and solid enough to stop the natural flow of liquid between the sections of wood on either side of it. If you're unsure whether your outline is up to the task, try using plain water on the area first and see how it behaves before you add any pigments. This kind of foresight and planning will save you a lot of work and will create a more enjoyable experience for you as the creator if you can get the results you're looking for the first time. After all is said and done, if your color still bleeds, you can always use an X-Acto knife and/or sandpaper to clean up your edges.

COLORING THE KOI

I colored the koi shown in the photos above with bright red, orange, tangerine, and white India inks. I blended the colors together to create various shades and applied them with a fine paintbrush. I used water to dilute the colors and to also help them blend. Notice how the colors cling really well to the exposed wood. While the colors are wet, it's very easy to simply wipe any excess ink off the burned areas because the pores of the wood in those areas are closed, so the ink won't soak in. If you allow the colors to fill in the crevices where you've burned deeper lines, those areas will be tinged with the color that was left there to dry, which can make your burned areas slightly obscured. Therefore, I recommend using a paintbrush or a paper towel to soak up excess ink from any burned areas that have accidental ink overflow.

NOTE: Any sealer can go on top of India inks. Because they're so permanent and because alcohol or other solvents won't affect them, you can be sure that whatever sealer you choose, your inks aren't going to run. And because they're lightfast, they won't fade when exposed to ultraviolet light. (But remember that woodburning does fade when exposed to ultraviolet light, so it's still recommended to use a sealer with UV protection.)

Troubleshooting

Here are some of the most common troubles you might have when starting on your woodburning adventure—and the solutions that will get you back to being creative and having fun again with this art form.

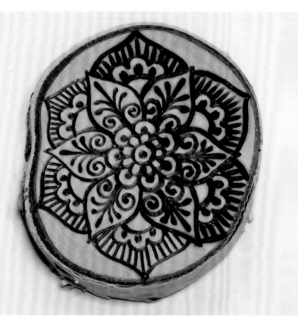

SCORCHING/OVERBURNING

Also known as overburning, scorching happens when you're woodburning at high heat and the area around where you're burning turns yellow from the ambient heat coming off your tool. This can give your artwork a sort of yellowish "glow," as if all your burned lines are outlined in yellow or orange. To combat scorching, simply turn down your temperature dial.

In the photo above, you can see that half the design was overburned. I burned this design with the same writing tip on two different heat settings. I burned the half that appears orangish on too high of a heat setting and I allowed the pen to linger too long on the design. I burned the other half at an appropriate heat setting and got a much better result.

TOOLS BENDING & WARPING

If your tools are getting "bent out of shape," they're not defective. You're simply putting too much downward pressure on your tip when you're burning. If you realize you're pushing harder than you would a pencil, ease up and let the heat do the job for you. If you need a darker burn, turn up the heat. Over time, pressing too hard on your tools will cause them to weaken and they could even snap or break off, costing you time and money to replace them. Some tools are more resilient than others and you'll learn which tools can take a bit of pressure and which are more fragile. If your tool does get bent, wait until it's cooled and use a pair of pliers to coax it back into shape. Next time, press lightly and be mindful of your heat setting.

UNEVEN SHADING

Several factors might cause uneven shading. Carbon buildup on the bottom of your tool might cause your tool to burn the wood unevenly. Try cleaning it with a scraper. (See page 15.) Your wood might have a rough texture that could need more sanding for a smoother surface. You could be putting uneven pressure on your tool or you might be burning too slowly and the excess heat is building up and scorching your wood. For many shading problems, the answer is to turn down the heat, go slower, and work gently in small areas at a time.

The wood might also have resinous pockets. This is mainly an issue with pine but applies to any wood with resin. When you burn over areas with resin, the wood itself doesn't burn easily. Instead, the resin boils up and creates a thick goop, which gets pushed around with the hot tool and sticks to the wood. For these areas, use the stippling method, use wood stain, or add coloring to try to even out the final look of the shading.

FADING

Fading happens when the base color of your wood darkens over time—thus causing your woodburned markings to disappear—or when ultraviolet light bleaches the image. For this reason, use a UV-protective sealer when you seal your artwork. Once your artwork has faded, there's no real remedy but to learn from the experience and do better next time. In order to prevent fading, keep your finished woodburnings out of direct sunlight and away from high humidity and moisture contact. The best defense against fading is knowledge of your wood species and the sealer you use. Oil-based sealers will darken the wood the most over time versus other kinds. See pages 50–53 for more on sealing.

COLOR BLEEDING

Color bleeding is when a coloring agent travels across the grain of your wood surface into areas you don't intend for it to go. It can create a problem deeper than the surface of your artwork if you're using liquid colors. Although mistakes do happen, you can prevent the unwanted bleeding of color by first creating connected burned outlines where you want the color to stay. If your color has still bled despite your careful touch, you can save your artwork by gently scraping away the dried, stained areas of wood with a flat blade. To see visuals of how to scrape your wood, see page 52. For more details about the best techniques for adding color, see pages 42–47.

BUMPY LINES

Bumpy lines happen when the grain of the wood you're using has exposed layers of softer and denser wood. The softer areas burn more quickly and intensely than the denser areas, so as you pull your tool across the surface, it snags on the denser parts and sinks into the softer parts. This is a common issue with pine, oak, and any wood with a visible grain pattern. You're more likely to experience this issue if you're using a rounded tip or a higher heat setting or if you're pulling your tool too quickly across the surface. The best remedy is to use a tool with a sharp edge, such as a curved knife, or the edge of an angled shader. Turn the heat down and burn more slowly, cutting through the grain as you go. You can use a gentle back-and-forth motion as you go for further emphasis.

Sanding the wood well before beginning is a great way to minimize the uneven look of prominent grain. However, you might find that even with sufficient sanding, this issue remains. In that case, switch the wood for a different species.

In the photo above, you can see two herons, which were outlined with a ball tip (left) and a curved knife tip (right). A ball tip skidded over the top of the grain pattern, causing the lines to be bumpy and uneven. A curved knife, though, sliced through the grain evenly. The result is a much smoother, more visually pleasing outline that will be a solid foundation for the rest of the artwork.

Sealing

Sealing your work can feel daunting at times, especially if you've dedicated many hours to your project. There are many choices out there and knowing the differences between them can help you make the best decision.

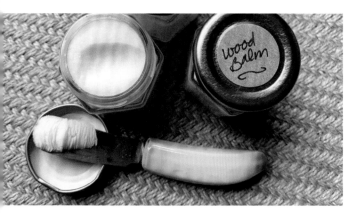

WHY SEAL YOUR ARTWORK?

If desired, you can leave your woodburned artwork unsealed. However, using an appropriate wood sealer can dramatically improve the longevity and durability of your project and keep it protected from various environmental factors that could contribute to the degradation of your art over time. For this reason, I recommend sealing your artwork as much as possible and soon after completion.

BEFORE YOU SEAL ANYTHING

Make sure all visible pencil lines are erased with a white pencil eraser. Pink erasers will leave big pink smudges on your wood surface. Toner smudges or other extraneous marks can be lightly sanded away from the surface. Make sure to wipe down your entire surface with a cloth to remove any dust, small particles, or fibers so nothing gets trapped forever between your sealer and your artwork.

FOOD-GRADE SEALERS

If your project will have anything to do with food—such as utensils, cutting boards, rolling pins, or bowls—you should make sure to use a high-quality and completely food-safe sealer. Luckily, there are many suitable food-grade sealers you could choose and they're all simple to apply.

Most sealers are made from oil, wax, or a combination of various oils and waxes. Oil penetrates into the wood to give it protection from moisture damage and brings out the rich hues of the wood, while wax fills the pores of the wood at the surface to create an easily wipeable and water-repellent coating. Mineral oil and butcher block oil are some of the most common choices for wooden kitchenware. As a lover of everything DIY, I also enjoy making my own food-safe wood sealer at home.

Homemade Wood Balm

For this recipe, use 1 part beeswax per 2 parts coconut oil. In a double boiler on your stovetop over medium heat, combine the beeswax and coconut oil. Once the ingredients start to melt, stir them to incorporate the wax and oil evenly. Once they're fully melted and stirred, carefully ladle the hot liquid into glass jars and let it cool. Use the balm by scooping small amounts of it with your thumb and rubbing the balm directly onto your project, letting the heat from your hands melt it in as you go.

BUTCHER BLOCK OIL

Butcher block oil is a well-known oil-based liquid sealer that's used to coat wood surfaces. As the name implies, butcher block oil is generally regarded as safe to come into direct contact with food and it's used to seal everything from kitchen items to furniture. It gives a deep and rich coloration to the wood it touches and conditions the wood to deter moisture damage. Although oil-based sealers do penetrate the wood fairly nicely, you might want to periodically recoat the wood with a fresh coating of this sealer to keep your item in top shape.

URETHANE SEALERS

Urethane sealers, such as polyurethane and spar urethane, are some of the most durable and permanent you could choose. I recommend a urethane sealer for most projects that aren't kitchen related. Fine art, wooden signs, keepsake boxes, and the like will all benefit from a durable coating. There are many kinds of urethane sealers available—each with different ingredients—but my favorite is spar urethane by Minwax, which is rated for the outdoors and comes with UV protection.

IMPORTANT QUALITIES TO LOOK FOR

UV Protection

Woodburning can and does fade over time if exposed to direct sunlight—just the same way colored paper will fade if left on a windowsill. Ultraviolet rays bleach colors and fade natural materials. UV protection is important with any work but especially with any outdoor signs that will be exposed to more sunlight than usual. Find a sealer with UV protection built into the formula.

Interior/Exterior

If your project is going to be exposed to outdoor conditions or excessive moisture or fluctuating temperatures, I recommend finding a sealer suitable for outdoor use. Exterior sealers are more durable and provide greater protection against the elements for the lifetime of your artwork. Interior sealers are best used when you know for sure your artwork will be kept in a suitable indoor environment.

FOLLOWING DIRECTIONS

Always read the directions carefully and follow them exactly. If ventilation is needed, make sure you have a well-ventilated space. Wait the proper amount of time between coats and sand between coats with 220 grit sandpaper to help the coats adhere properly to one another. Getting a nice, smooth finish is often the simple result of making use of some sandpaper and a high-quality paintbrush.

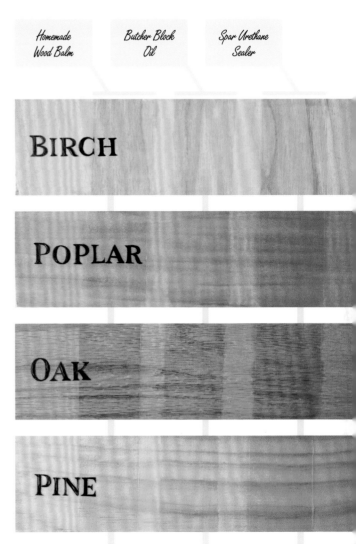

Homemade Wood Balm | Butcher Block Oil | Spar Urethane Sealer

BIRCH

POPLAR

OAK

PINE

MAPLE

BASSWOOD

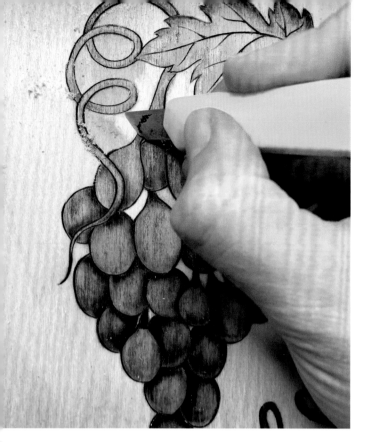

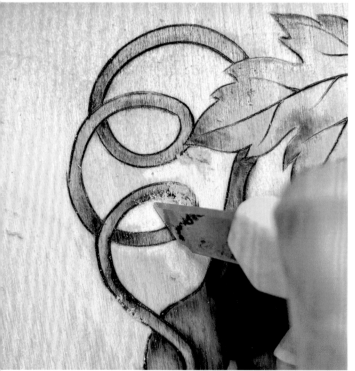

HOW SEALERS CAN AFFECT YOUR ARTWORK

Warping

Always seal both sides of a project, not just the front side. You want to seal both the front and back of your artwork, wooden signs, etc., so when your wood art is out in the world and is exposed to different levels of humidity and temperature, it will be able to withstand those fluctuations. If the front of your artwork is sealed, the pores of the wood on that side will be closed. And if the back is left unsealed, the pores on the wood will be able to absorb moisture from the air and expand, causing your wood to be unevenly hydrated, which can lead to warping. Your once perfectly flat wooden artwork will now be concave—or worse yet, it could develop a split in the wood grain over time.

Using Sealers Over Color

When using sealers over color, you need to combine them in the right way to avoid an unwanted chemical interaction. If you've added color to your work with watercolors, don't choose a water-based sealer! A water-based sealer can redissolve the watercolor paints and you'll effectively smear your watercolors all over your artwork. Trust me, you don't want this to happen. If you used watercolors in your artwork, use an oil-based sealer over the top of them.

Remember, oil and water don't mix. For sealing your artwork, that's a good thing. If you used some oil-based color, you'll want to avoid an oil-based sealer and opt for a water-based acrylic or polyurethane. If you used permanent ink, wood stain, or acrylic paint, you can use any sealer you like because these are indestructible once dry. Sometimes, using a spray fixative can help prevent any colors from running.

In the photos at left, you can see how a water-based sealer has dissolved the green watercolor paint that was used to color these grapevines. The only remedy for a problem like this is to wipe off as much of the sealer as you can, let it dry, and painstakingly scrape down the affected area with a sharp blade to remove the stained wood and reveal a new layer of wood beneath. Once these areas were scraped down entirely, the work was sealed with an oil-based sealer without a hitch.

Darkening the Wood

No matter what sealer you use, you can bet the color of your wood will darken—if only slightly. The kind of wood you use and the kind of sealer you choose for your wood will determine the degree to which your base wood color darkens. Look at the wood chart on page 51 to see how each kind of sealer has changed the color of each of the woods. Keeping these color values in mind before you begin your project will help you visualize how your final product might look. Of course, every piece of wood is its own unique entity, and with time, your experience with each kind of wood will help you predict the outcome and plan accordingly. If you're ever unsure of just how dark your wood will be when sealed, wipe a small section of the wood with a water-moistened cloth and observe the change in color between the wet wood and the dry wood. When sealed, wood appears similar to the color it is when wet.

Because you know your wood will darken slightly when sealed, you're right to infer that some of the contrast in your artwork will appear less vivid after sealing. If you're woodburning a subtle image with light shading, don't choose to use a darker wood like oak. Once you seal the oak, the base color of your wood will darken significantly and some of your light shading will effectively disappear into the background. As you can see, basswood is the safest choice for preserving the original design as much as possible because even when sealed, basswood is still very light in color and won't darken your image as much as other woods. Darker or more pigmented woods look best with bold lettering or darkly shaded designs that will stand out against the background.

In the photo at bottom right, you can clearly see the darkening of the wood with the addition of the sealer. On the right half of the bowl, my wood balm has been rubbed into the wood and the left side is still dry and unsealed. Notice the difference in color between the legs on the left side and the right side. The base wood color is much richer when sealed and some of the contrast is naturally muted.

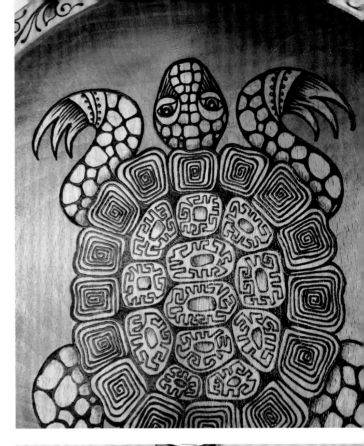

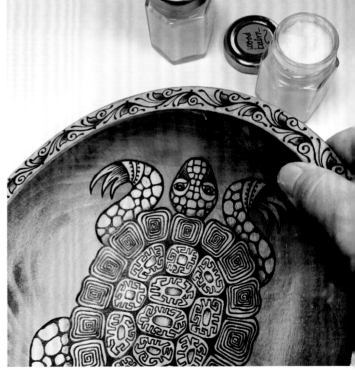

Chapter 2
The Projects

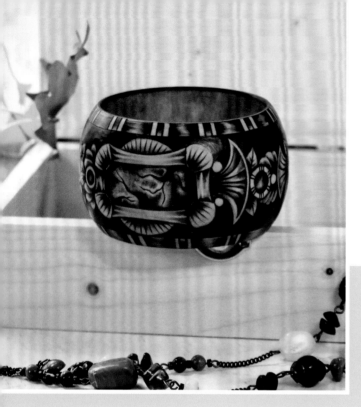

Bangle

Level: **Beginner**
Template: **Decorative Borders (pg. 91)**
Tools Used:

Curved Knife Angled Shader

Create a unique piece of statement jewelry by burning a design onto a raw wooden bangle! Accessories like this are simple to personalize and they make beautiful, one-of-a-kind additions to your wardrobe.

What You'll Need:

- Unfinished wooden bangle
- Brush-on wood stain (optional)
- Oil-based sealer

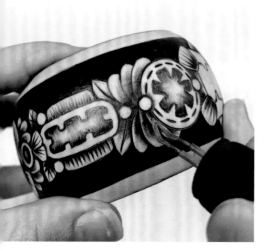

The Process:

- **Before burning:** Tape the template onto the wood and transfer the design with the tracing method.

- **Beginning to burn:** Burn the outlines with a curved knife. If you want to add the geometric border, use a pencil to draw a straight line parallel to the edge of the bangle. Use an angled shader to carefully burn the area between the pencil line and the outer edges of the traced design solid black.

- **Shading:** Use an angled shader on medium heat for shading. Shade intuitively, creating areas of shadow and light. Shade in small sections from the inside out or the outside in to create a 3D effect. The darker areas will fade into the background and the lighter areas will come forward in the design. Play around with the shading to make the design come to life in your own unique way!

- **Embellishing:** Use an angled shader to add details to the geometric edging. Add any extra details you desire, combine more than one template, or make the background one solid color.

- **Finishing touches:** Stain the inside of the bangle with a brush-on wood stain. Seal the bangle by rubbing an oil-based sealer directly onto the wood with your fingers.

Pendant

Level: **Beginner**
Template: **Birds (pg. 104)**
Tools Used:

Curved Knife Writing Tip Spoon Shader

Jewelry pieces like this necklace are a creative way to give your artwork a functional flair! Wearable art doesn't have to be big or complicated. No matter your personal style, there's a wooden pendant for you.

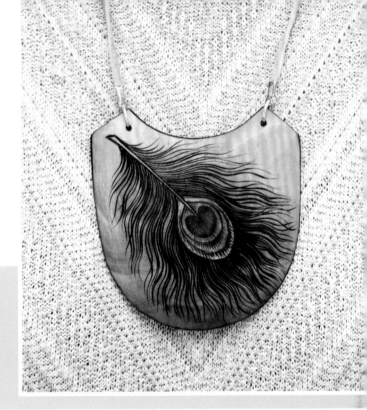

What You'll Need:

- Unfinished wooden pendant
- Watercolor paints
- Oil-based sealer
- Necklace chain and findings
- Jewelry pliers

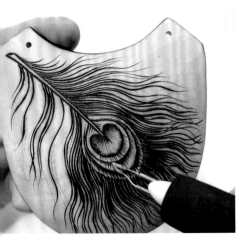

The Process:

- **Before burning:** Tape the template onto the wood and transfer the design with the tracing method.

- **Beginning to burn:** Use a curved knife to create the individual feather strands by making randomized, flowing strokes. The feather's wavy pattern is a good guideline, but experiment and add variation for a realistic effect. Burning slower or with higher heat will result in thicker strands, while burning quicker or on a low-heat setting will result in thinner, wispier strands. Use a writing tip on low heat to add details to the circular center.

- **Shading:** Use a spoon shader to shade outward from the center ridge of the feather to create contouring in the shape of the feather. The darker, more saturated color is near the center, and as you move outward, all details and color should fade evenly.

- **Embellishing:** Add a blue-green wash of color with watercolor paint, being careful to use a small amount and blend outward from the middle until the feather reaches your desired vibrancy.

- **Finishing touches:** Seal the pendant by rubbing an oil-based sealer directly onto the wood with your fingers. Use jewelry pliers to attach the necklace chain and findings.

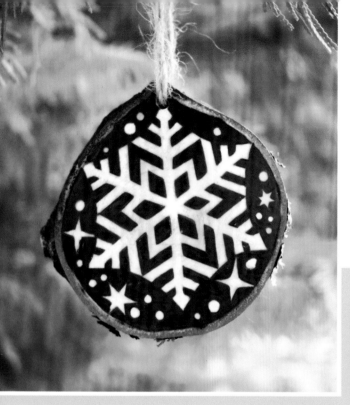

Ornament

Level: Beginner
Template: Miscellaneous (pg. 122)
Tools Used:

Curved Knife Writing Tip Angled Shader

This classic snowflake ornament brings to mind the magic and beauty of the winter season—a great woodburning project for a chilly day and the perfect handmade gift to add charm to a loved one's home.

What You'll Need:

- Unfinished wooden disc
- Acrylic paint (optional)
- Spray-on polyurethane sealer
- Hemp or jute cord

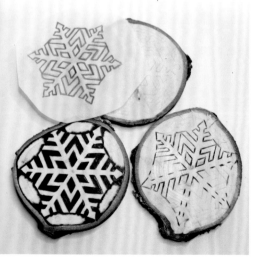

The Process:

- **Before burning:** You can choose from two different snowflake templates. This particular ornament uses the larger snowflake template. Tape the template to the wood and transfer the design with the tracing method.

- **Beginning to burn:** Create the sharp, straight outlines with a curved knife. When working with geometric designs, burn them by grouping parallel lines together. Burn all the straight spokes outward and then the parallel lines between them. This makes the snowflake look uniform and symmetrical.

- **Shading:** This ornament has no shading—it's all solid black.

- **Embellishing:** For extra detail, draw additional small circles and starburst shapes with a pencil. Burn around these circular spaces with a writing tip. Burn the rest of the background black with an angled shader. Use medium heat and take your time to maintain the crispness of the edges and corners.

- **Finishing touches:** Add a white pearl acrylic paint to parts of the design to help it pop. Drill a hole into the top for the cord. Seal the entire ornament. Any wood sealer would work great for this project, but I used a spray-on polyurethane.

Wooden Egg

Level: **Beginner**
Templates: **Animals (pg. 98)**
Decorative Borders (pg. 93)
Tools Used:

Curved Knife | Writing Tip | Spoon Shader | Angled Shader | Ball Tip

This Ukrainian-inspired wooden egg makes a beautiful keepsake to cherish for years. From holidays to birthdays and other milestones, commemorate the day with a memento you can enjoy all year.

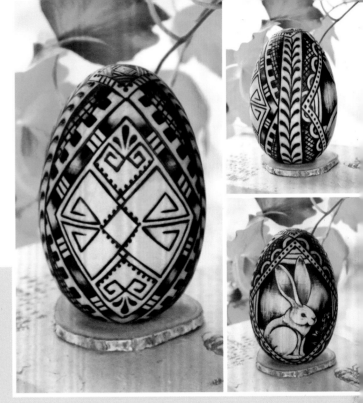

What You'll Need:

- 3-inch-tall unfinished wooden egg with a flat bottom
- Oil-based sealer

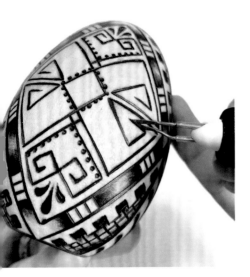

The Process:

- **Before burning:** Tape the template to the wood and transfer the design with the tracing method. Curved surfaces are tricky, so transfer the main guidelines first. Remove the tracing paper and use a pencil directly on the wood to fill in the other details.

- **Beginning to burn:** Use a curved knife to trace all the straight lines. This creates a sharp, precise outline as well as a clean look to the geometric-patterned areas. Use a writing tip to outline especially curvy areas, such as the rabbit and the vine pattern.

- **Shading:** Use a spoon shader on low heat to shade the rabbit, using careful circular motions. Use an angled shader to add shadow to the geometric areas, creating strong contrast. Adding shading makes the design more whimsical and dimensional. Shade slowly in layers until you achieve the right balance.

- **Embellishing:** Add some extra texture by using a ball tip to create a stippled outline on the geometric areas. Traditional Ukrainian eggs have bright multicolored patterns. You could add acrylic paint after the burn to create a similarly eye-catching look.

- **Finishing touches:** Seal the egg by rubbing an oil-based sealer directly onto the wood with your fingers.

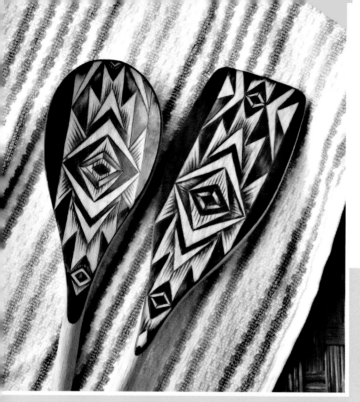

Utensils

Level: **Beginner**
Template: **Decorative Borders (pg. 93)**
Tools Used:

Curved Knife Angled Shader

Turn two of the most widely used cooking utensils into beautiful works of art. With this charming wooden spoon and spatula set, you can serve up new levels of creativity in your kitchen in no time.

What You'll Need:

- Unfinished wooden spoon and spatula, sanded smooth
- Food-grade sealer

The Process:

- **Before burning:** Tape the same template onto each utensil and transfer the designs with the tracing method.

- **Beginning to burn:** Use a curved knife to burn over the traced lines, prioritizing precision over speed. Because this geometric design looks best with neat, straight lines, it favors sharp and angular tools. Once the outlines are crisply rendered with a curved knife, use an angled shader to fill in the details.

- **Shading:** Use an angled shader to create dimension in the design by using the pointed tip and straight edges to shade within the angular nooks. This bold look is created when dark, light, and medium values are arranged in a balanced way throughout.

- **Embellishing:** Small details, such as the parallel lines added to some areas, can add visual interest and a pop of texture. Create the strips of solid black around the edges to finish off the look.

- **Finishing touches:** Liberally coat the utensils with a food-grade sealer, such as wood balm (page 50), butcher block oil, or mineral oil, by rubbing the sealer directly onto the wood with your fingers or with a soft cloth. Reapply the sealer to the utensils any time you feel they're getting too dry. And always wash them by hand!

Coasters

Level: **Beginner**
Template: **Mandalas (pg. 97)**
Tools Used:

| Curved Knife | Writing Tip | Angled Shader | Ball Tip |

Upgrade your favorite beverage nook with a set of conversation-starting coasters! With dazzling mandala designs, these wood coasters pack a visual punch in the form of functional pieces of home decor.

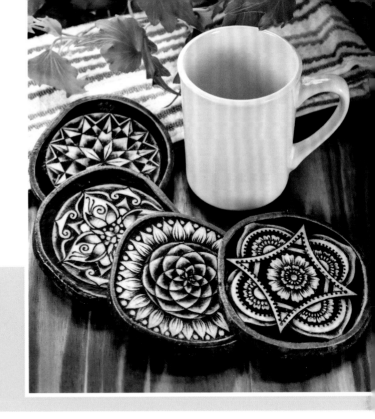

What You'll Need:

- 4 unfinished maple wood discs (3 to 4 inches in diameter)
- Waterproof polyurethane sealer
- 200 grit sandpaper

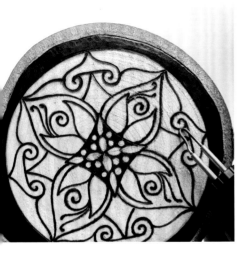

The Process:

- **Before burning:** Tape four different mandala templates onto the wood and transfer the designs with the tracing method. For a matching set, you could use the same design for each disc.

- **Beginning to burn:** Use a curved knife to burn all the straight outlines. For the curvier designs, such as the henna-inspired imagery, use a writing tip. Burn slowly and with precision.

- **Shading:** Create depth by shading the design with an angled shader. Shading the edges and corners of shapes helps the areas around them stand out. There are countless ways to shade these designs, so you could try to replicate the shading you see here or discover new ways to shade them by experimenting!

- **Embellishing:** Use a ball tip to create some added flair to the diamond-shaped mandala. Customize your coasters in various ways, including adding color or stain. Remember to add any embellishments before moving on to the sealing process.

- **Finishing touches:** Use a soft-bristled paintbrush to carefully apply many thin coats of a waterproof polyurethane sealer. Remember to follow the directions recommended on the label, such as sanding between coats to give the proper hold.

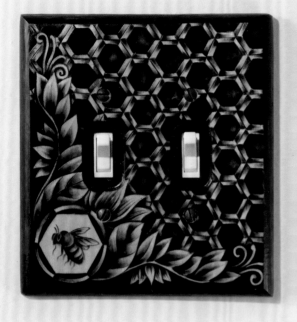

Light Switch Cover

Level: **Beginner**
Template: **Bees & Butterflies (pgs. 108–109)**
Tools Used:

Curved Knife Angled Shader Writing Tip

Add an artful touch to an often overlooked part of your wall: the light switch cover! From bedrooms to bathrooms to dining rooms, each light switch is an opportunity to add character to your chosen space.

What You'll Need:

- Unfinished wooden light switch cover
- Brush-on polyurethane sealer

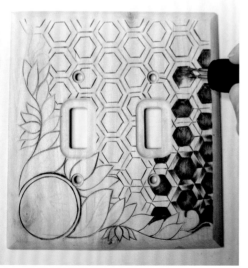

The Process:

- **Before burning:** Combine two templates for this project by tracing the outline of the light switch cover onto translucent paper and cutting out that shape. Use that cutout as your template by tracing the honeybee corner design and honeycomb pattern directly onto the cutout with a pencil. Tape the whole template to the wood and transfer the design with the tracing method.

- **Beginning to burn:** Burn the outlines with a curved knife. For the honeycomb, burn them in groups of parallel lines. For a cool effect, once you burn the basic structure, add a small hexagon within each larger hexagon and connect each corresponding corner by a straight line. Burn the honeybee with a writing tip.

- **Shading:** Use an angled shader to darken inside each small hexagon. Shade the rest of the hexagonal panels from dark to light counterclockwise. Darken the areas around the swirly corner design to help it stand out.

- **Embellishing:** Burn the outer edges and the bevels around the actual switches with an angled shader to give a polished effect.

- **Finishing touches:** Seal the light switch cover with three coats of a brush-on polyurethane sealer.

Magnets

Level: **Beginner**
Template: **Miscellaneous (pg. 120)**
Tools Used:

Writing Tip Angled Shader Fine Detail Tip

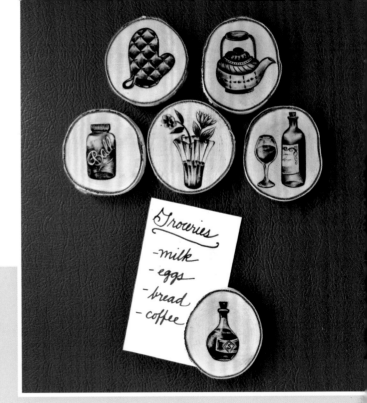

Make your refrigerator more attractive with a set of woodburned magnets! These classic designs are perfect to use year-round, but you can choose other designs to match your kitchen decor or your personality.

What You'll Need:

- 6 unfinished birch wood discs (2 to 3 inches in diameter)
- Spray-on polyurethane sealer
- Magnets
- Strong glue

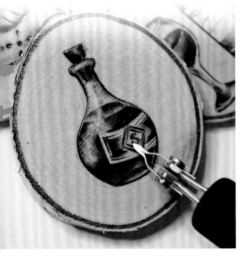

The Process:

- **Before burning:** Tape the templates onto the wood and transfer the designs with the tracing method.

- **Beginning to burn:** Trace the general outlines of each template by using a writing tip on low heat. Continue to use that writing tip to add details, such as those on the oven mitt, teakettle, and vase of flowers.

- **Shading:** Use an angled shader to create the shading on all the magnets. Gradually shade most of the images from the outer edges of the design toward the middle to create a rounded effect. Give the glass bottles extra areas of darkness and extra areas of lightness to mimic the effect of glare on the glass. If needed, find a reference photo or use a wine glass to observe this lightplay before trying to render it in your artwork. It's a fun way to add some extra challenge to this simple project.

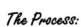

- **Embellishing:** Create tiny embellishments with a fine detail tip, such as decorating the labels on the glass bottles. You can improvise little touches like this to suit your style.

- **Finishing touches:** Seal both sides with a spray-on polyurethane sealer and glue a magnet to the back of each disc.

Wooden Sign

Level: **Beginner**
Template: **Mandalas (pg. 96)**
Tools Used:

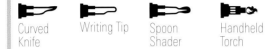

Curved Knife | Writing Tip | Spoon Shader | Handheld Torch

Whether on your front door or hanging in your office, a wooden sign can bring good energy to your life by reminding you what's meaningful. You can easily burn any phrase onto a wooden sign.

What You'll Need:

- Unfinished wooden plaque
- PyroPaper
- Spray-on polyurethane sealer
- Jute cord
- Staple gun

The Process:

- **Before burning:** Use a word-processing document to type your words, size them appropriately for your project, and print them on PyroPaper. Tape the PyroPaper to the wood and transfer the letters using the PyroPaper method. For a decorative touch, add the two corner designs with the tracing method.

- **Beginning to burn:** Burn the outlines of the letters directly through the paper with a curved knife on low heat. Trace the edges precisely. Remove the PyroPaper from the surface. Fill in the letters with a writing tip, carefully coloring in the spaces between the outlines to create solid letters. Use a writing tip to outline the corner designs.

- **Shading:** Use a spoon shader to shade away from the outer edges of the corner designs, fading out to the natural wood color to give a slightly embossed effect.

- **Embellishing:** Use a handheld torch to darken the beveled edges, giving the sign a framed effect. You could also paint the edges with acrylic paint, leave them naturally wooden, or burn them using any shading tip.

- **Finishing touches:** Seal the entire sign with three coats of a spray-on polyurethane sealer. For exterior signs, make sure you're using a weatherproof sealer and letting it cure the recommended amount of time before exposing it to the elements. For indoor signs, your preferred sealer will work great. Staple a jute cord to the back of the sign and hang your new artwork wherever you desire.

For this sign, I used pine wood. You could choose to use any kind of wooden plaque—as long as it's unfinished. When working with pine, it's important to protect your lungs from any resinous smoke that might waft toward you by wearing the appropriate safety gear. I recommend burning on a lower heat setting to avoid scorching and using a sharp-edged tip, such as a curved knife, to cut through the grain.

Cutting Board

Level: **Intermediate**
Templates: **In the Garden (pgs. 114–115)**
Tools Used:

Writing Tip Angled Shader Spoon Shader Ball Tip

This detailed cutting board celebrates fresh flavors and wholesome ingredients! Combining food and art is always a good idea and this foodie-friendly project is a great way to do just that.

What You'll Need:

- Unfinished maple wood cutting board
- Food-grade sealer

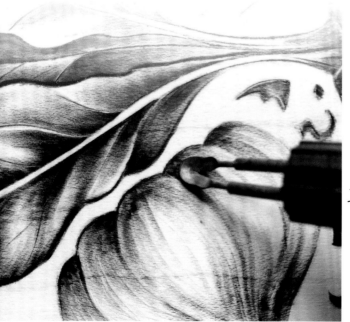

The Process:

- **Before burning:** Trace an outline of the cutting board onto a translucent piece of paper and cut that shape out. Use that cutout as a master template on which to trace a collection of individual food-themed templates, filling the space artfully. Tape the master template onto the wood and transfer the whole design with the tracing method.

- **Beginning to burn:** Burn the curvy outlines with a writing tip and burn the straight outlines with the edge of an angled shader.

- **Shading:** Create dimension in this design by shading areas of light and shadow to bring out the natural shapes and textures of the foods. Use low heat and slowly build up your layers of shading. Use a spoon shader to perfect the subtle tonal differences. Use an angled shader in areas with sharp corners or that are too thin for a spoon shader. Give the lemon a stippled texture with a ball tip. Because this wood is so light in color, shade inward from the edges of each image to create crisp, dark silhouettes.

- **Embellishing:** To keep this as a functional cutting or serving board, don't add any further embellishments beyond the shading. This keeps the board food-safe and nontoxic.

- **Finishing touches:** Butcher block oil applied with a soft cloth is a superior choice for sealing this board, but any food-grade sealer will work.

If you cut on top of the imagery you've burned, the knife might create small scratches in your design. If you want to preserve the imagery for a long time, consider using the back of the cutting board for cutting and the decorative side for serving fancy cheeses and for displaying on your wall when not in use. Always re-oil any wooden kitchen items as needed to keep them looking their best.

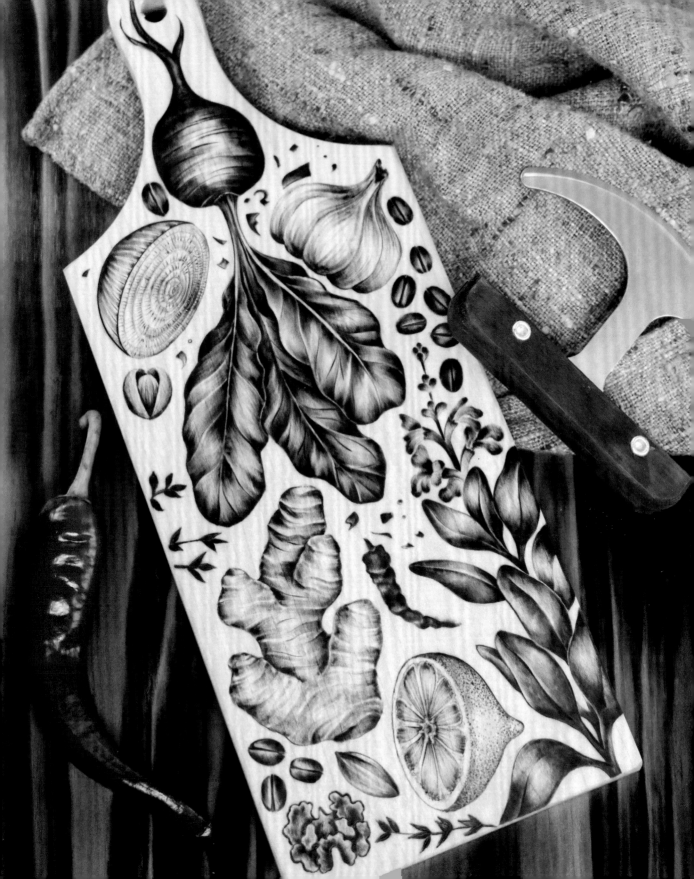

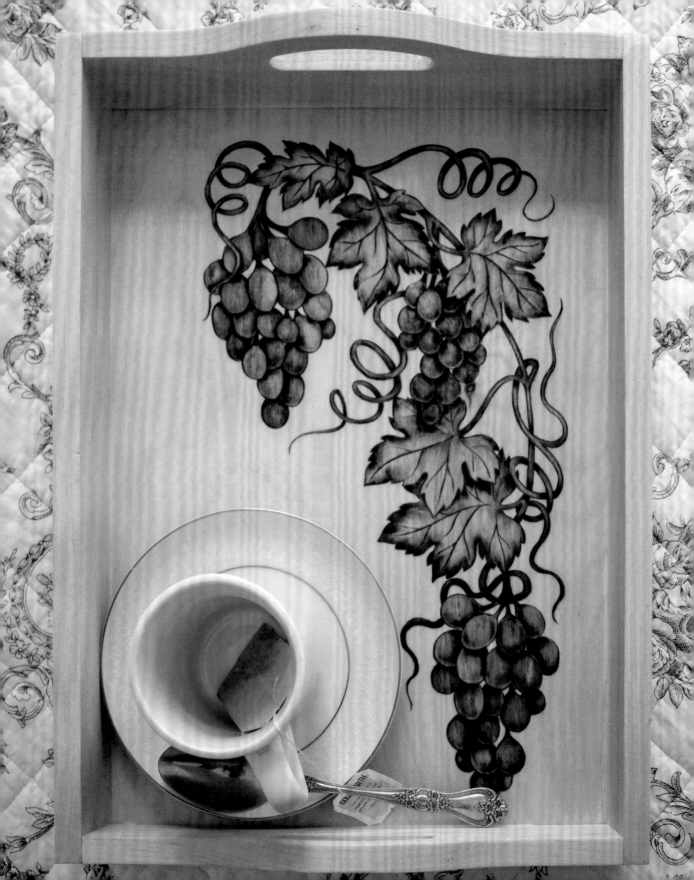

Serving Tray

Level: **Intermediate**
Template: **In the Garden (pg. 112)**
Tools Used:

Curved Knife Spoon Shader

This serving tray makes breakfast in bed a special event! With a classic grapevine design, this cozy and useful item will add sophistication to any bedroom. This project allows you to practice shading gradients.

What You'll Need:

- Unfinished basswood serving tray
- Watercolor paints
- Oil-based sealer

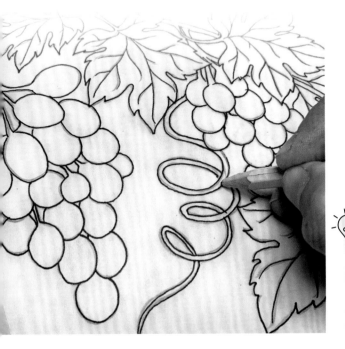

The Process:

- **Before burning:** Tape the grapevines template to the wood and transfer the design with the tracing method. Add a third cluster of grapes to fit better with the shape of the tray. Draw the third cluster with a pencil by observing the shape of the first and roughly copying it. If you're unsure of your ability to draw a cluster of grapes on your own, you could transfer one of the other clusters and add or subtract a couple grapes to change it slightly.

- **Beginning to burn:** Burn the outlines using the curved knife on low heat. Because you'll add watercolors, be sure to burn your outlines deep enough to stop the flow of water across the grain. This way, the paint stays within the grape or leaf shapes as intended.

- **Shading:** Use a spoon shader to carefully build up the shading layer by layer, using circular strokes on low heat. Burn the shadows beneath each grape first and then shade the edges of each grape inward to create the rounded lifelike effect. (See page 27 to view more photos of the grape-burning process.) Shade the edges of the leaves to help them stand out against the light background.

- **Embellishing:** Use a light wash of watercolor paint to bring the grapes to life. They look more lifelike if some of the grapes are slightly different colors, so paint some darker and some lighter for a contrasting effect.

- **Finishing touches:** Seal the tray by rubbing an oil-based sealer directly onto the wood with your fingers or with a soft cloth. Make sure to coat the serving tray evenly and get the sealer into all the corners for the best protection and a finished look.

The tall sides of the serving tray might create a challenging angle for your hands when you're burning this design. Play around with the placement of the serving tray in front of you to find a comfortable angle. If you're hovering or feeling shaky, use your nondominant hand to stabilize the hand you're burning with.

Picture Frame

Level: **Intermediate**
Template: **Bees & Butterflies (pgs. 110–111)**
Tools Used:

Transfer Tip Curved Knife Writing Tip Ball Tip

This magical array of colorful butterflies is easier to create than it looks! With simple outlines and the vibrancy of watercolor pencils, this project is a great way to practice linework and coloring.

What You'll Need:

- Unfinished basswood frame
- Watercolor pencils
- Brush-on polyurethane sealer

The Process:

- **Before burning:** Print each individual template onto translucent paper with a laser printer. Cut the shapes out and tape them in place around the frame in a pleasing way. Transfer the designs with the heat transfer method and a transfer shader tip.

- **Beginning to burn:** Burn the outlines of all the butterflies using a curved knife and a writing tip in tandem. Use a curved knife for all the straight lines and use a writing tip for the small details and the curvy areas. Draw the moon and stars with a pencil and fill in the background of the night sky with black stippling by using a ball tip. Fade the stippled dots outward from the corner to blend them into the rest of the background.

- **Shading:** This has minimal shading—just some dark areas added to the wings of some of the butterflies. Because you'll use watercolor pencils for this and because you'll want the color to look its best, the color needs to soak into the wood evenly. When shading normally, the heat from the tool you're using essentially burns the pores of the wood shut and creates a slippery carbon surface, which watercolor pencils won't soak into or adhere to. Therefore, you won't shade the butterflies with a shading tool. Instead, you'll create the shading with color after you're finished with the woodburned parts of this design.

- **Embellishing:** Use dry watercolor pencils to color directly onto the wooden surface. Layer multiple colors together to create a blending effect. When finished with all the dry coloring, use a damp paintbrush to liquefy the colors and bond them to the wood. When wet, the colors blend together just as paint does and they have a seamless and vibrant quality. (See page 42 for more on the dry watercolor method.)

- **Finishing touches:** Seal the entire frame with a brush-on polyurethane sealer.

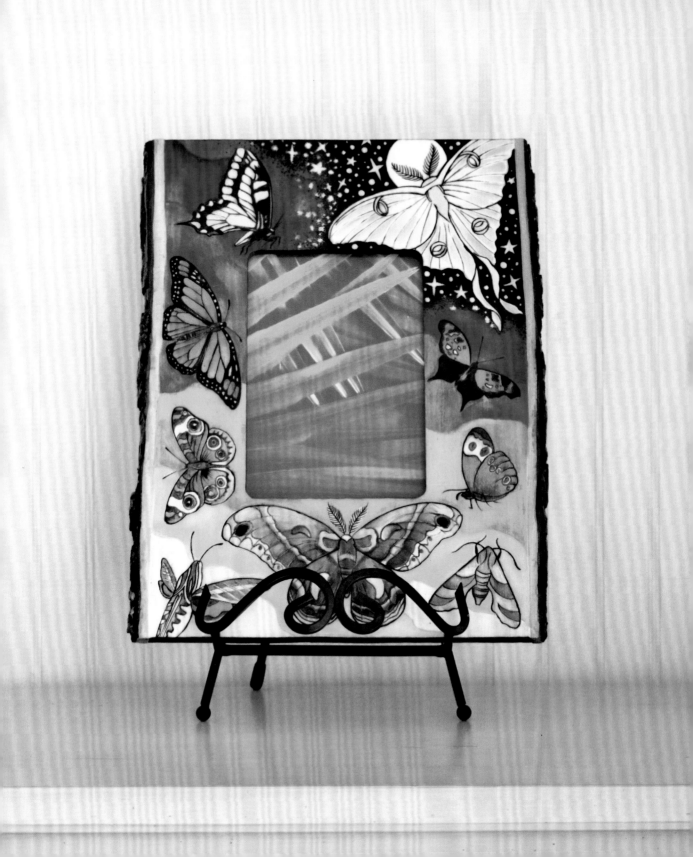

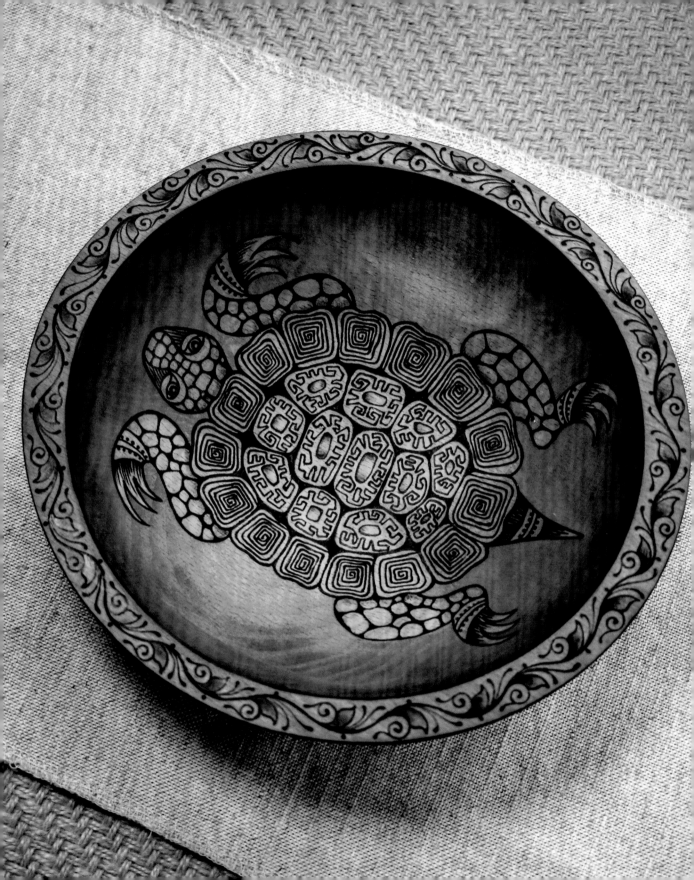

Decorative Bowl

Level: **Intermediate**
Template: **Animals (pg. 100)**
Tools Used:

Transfer Tip Writing Tip Spoon Shader

This decorative bowl gives you the chance to practice burning on a curvy surface while also creating an eye-catching centerpiece for your table, a catchall for your keys, or a display for your most-worn jewelry.

What You'll Need:

- Unfinished maple wood bowl
- Brush-on wood stain
- Oil-based sealer

The Process:

- **Before burning:** Use a laser printer to print the turtle template. Tape the template facedown on the inside of the bowl, making several thin folds in the template to mold it snugly to the curve. Carefully transfer the design with the heat transfer method and a transfer shader tip.

- **Beginning to burn:** Use a writing tip on medium-high heat to burn over the lines of the design. Because this design is so bold and the linework is thick, use a writing tip slowly and make sure to go over the lines several times, ensuring the burned areas are dark and crisp.

- **Shading:** Use a spoon shader to create a subtle gradient on the legs, face, and shell. Shade the center circle of each shell plate from one side to another. Shade the head, legs, and tail to give a bit of separation between the shell and the rest of the body.

- **Embellishing:** Draw the vine design on the outside of the bowl freehand with a pencil. You could replicate my design with a writing tip or you could use your creativity to add a different border. It would also look striking to burn a solid black rim around the bowl.

- **Finishing touches:** Coat the inside of the bowl between the turtle and the rim with a brush-on wood stain to darken it and bring out the richness in the wood. Paint the bottom of the bowl with the stain, leaving the rim of the bowl as well as the turtle design natural. Once the wood stain has dried, seal the entire bowl by rubbing an oil-based sealer directly onto the wood with your fingers.

Rolling Pin

Level: **Intermediate**
Template: **Decorative Borders (pgs. 90 & 93)**
Tools Used:

Transfer Tip Curved Knife Angled Shader

A customized wooden rolling pin is a meaningful gift for the baker at heart. Whether used as intended or as kitchen decor, this project is sure to bring inspiration to your next batch of cookies.

What You'll Need:

- Unfinished wooden rolling pin
- Food-grade sealer

The Process:

- **Before burning:** This woven pattern resembles the lattice crust on a pie. Print the image onto translucent paper, tape the template to the wood, and transfer the design with the heat transfer method and a transfer shader tip.

- **Beginning to burn:** Burn the transferred pattern with a curved knife, working in groupings of parallel lines. Create the accent lines showing texture with the same tool, using varying lengths of strokes.

- **Shading:** Use an angled shader to shade the dark squares between the woven shapes. Shade each small piece of the lattice pattern one at a time. Shade each section toward its center from the edges that meet the perpendicular overlapping piece next to it. This is what creates the 3D appearance of the design. The bolder your shading, the more depth the design will appear to have.

- **Embellishing:** To keep the rolling pin food-safe and functional, stick with plain designs. Textures and little snippets of your burned design might show up in your dough, but they aren't intended to decorate your dough like some engraved rolling pins are. If you add color or other embellishments, the rolling pin will no longer be food-safe but could be a beautiful kitchen decor piece. Inks or stains would be the best decorative color choices.

- **Finishing touches:** Seal the rolling pin by rubbing a food-grade sealer, such as wood balm (page 50), butcher block oil, or mineral oil, directly onto the wood with your fingers or with a soft cloth.

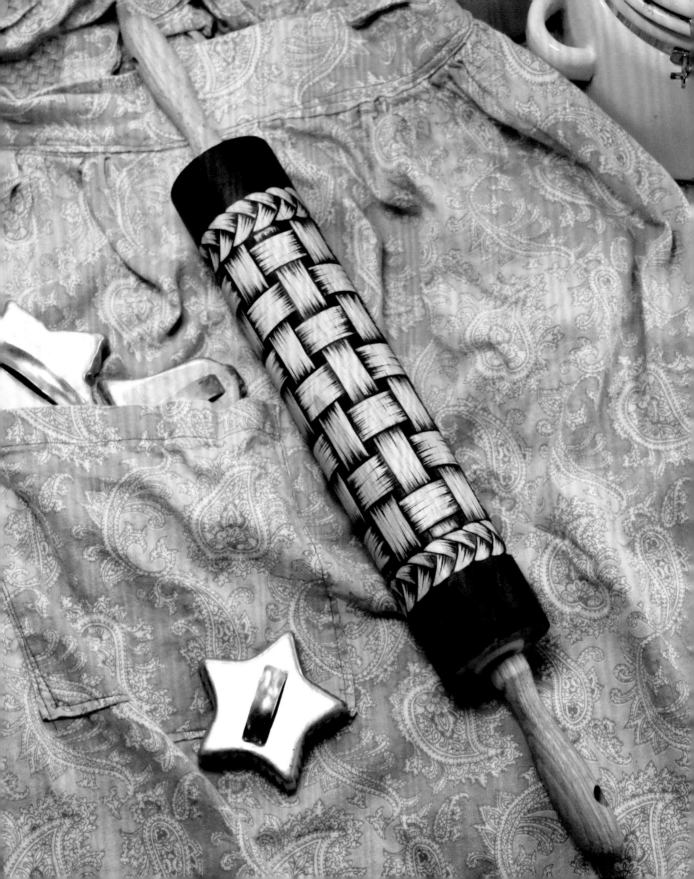

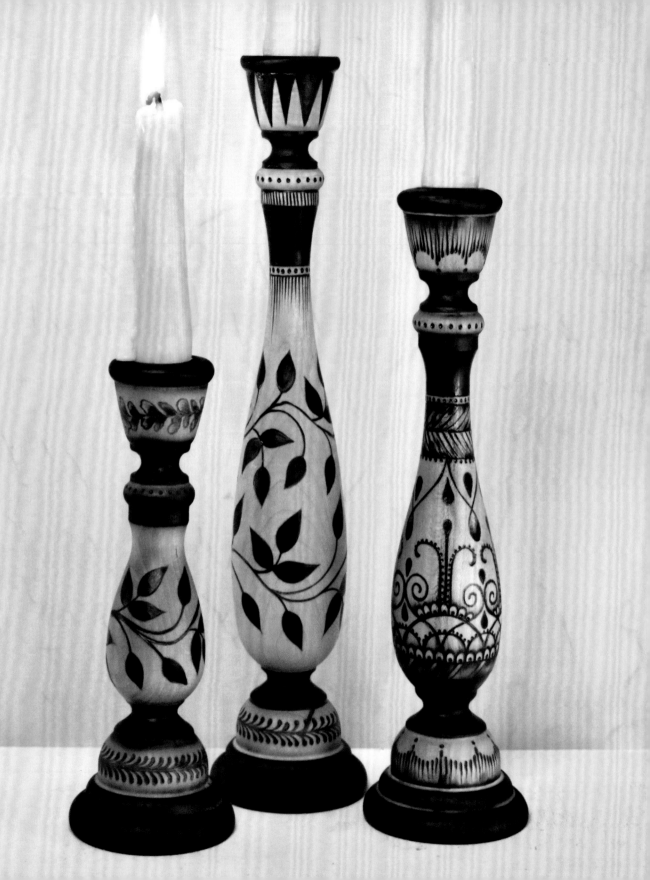

Candleholder

Level: **Intermediate**
Template: **Decorative Borders (pg. 90)**
Tools Used:

Angled Shader Writing Tip Handheld Torch Ball Tip

Candleholders can add an earthy and intimate touch to any space. For this project, use a handheld torch and pyrography tools to create sophisticated decor that can lighten up any room.

What You'll Need:

- Unfinished birch wood candleholders
- Oil-based sealer

Always have proper ventilation. Torches create excessive smoke, so outdoors is the ideal place to use one. Using steady back-and-forth motions, wave the torch above the surface of the wood without letting the tip touch the wood. The longer you hover in one place, the darker your burn.

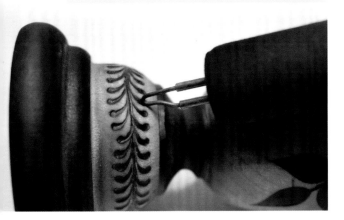

The Process:

- **Before burning:** Use a pencil to replicate these templates because you won't want to fuss with transfer paper on these dynamic and curvy surfaces. Such designs as flowing vines, simple flowers, or stripes can work well on this style of candleholder. Add the additional decorative patterns on these candleholders by hand. Experiment with different patterns to create a more plain or a more bohemian look.

- **Beginning to burn:** Burn the darkest areas of the candleholders with a handheld torch. Because traditional shading tips have limited surface contact with a tightly rounded surface, it's much more time efficient to use the torch in tricky areas. Complete the torch work before the rest of the burning. Use a writing tip for the outlines.

- **Shading:** These designs didn't need much shading because the effect left by the torch gave them just the right amount of contrast. However, use an angled shader to create some areas of shading in the designs for a little pop of dimension. Use an angled shader to also burn the leaves dark. After all the major elements of the design are complete, use a ball tip to add stippled embellishments to some of the lines. Dots added along a curved line give more texture and visual interest.

- **Embellishing:** Leave the candleholders plain to allow the natural wood color to come through or add a light wash of color or some wood stain to add flair or to match them to your home decor. Remember to always add color before the sealing process.

- **Finishing touches:** Seal the candleholders by rubbing an oil-based sealer directly onto the wood with your fingers. Make sure to coat all the small crevices. Also, ensure your sealer isn't flammable or reactive to heat if you choose to light candles in these holders.

Clock

Level: **Intermediate**
Templates: **Birds (pg. 102)**
 Botanical (pg. 116)
Tools Used:

Angled Shader Writing Tip Ball Tip

Curved Knife Spoon Shader

> This project incorporates several coloring methods, but you could use only watercolor pencils to achieve this look. You can mix and match templates so your clock reflects your personal style.

What You'll Need:

- Blank 14-inch basswood clock face, sanded smooth
- PyroPaper
- India inks
- Watercolor pencils
- Wood stain
- Spray-on polyurethane sealer
- Clock hands and mechanism

💡 Whenever you're using multiple kinds of coloring mediums, make sure to begin with the liquid inks and stains first and let them dry before adding watercolor paints or pencils. Watercolor pencils are less permanent and will blend whenever moistened, so it's best to use them last.

The Process:

- **Before burning:** Use a word-processing program to type the numbers 1 through 12, print them, cut them out, and transfer them onto the clock using the PyroPaper method. Print the cherry blossom and chickadee templates onto translucent paper, arrange them facedown on the clock face, tape the templates to the wood, and transfer the designs with the heat transfer method and a transfer shader tip. Use a pencil to create the concentric circles around the edges. Trace a small circle in pencil around each number.

- **Beginning to burn:** Burn the outlines of the numbers through the PyroPaper with an angled shader. Remove the PyroPaper before coloring the numbers in with a writing tip. Use a ball tip to stipple the circles around each number. Use a curved knife to create the concentric lines of the clock border. Use a curved knife or a writing tip to create precise outlines of the flowers and birds. Because you'll color with a liquid ink, create a deep enough outline to ensure the colors won't run through your burned edges. If your outlines are too shallow, the color could travel across the surface through the wood grain, spilling into areas you don't want it to go.

- **Shading:** Use a spoon shader to add some light shading to the chickadees and branches.

- **Embellishing:** Use a paintbrush to blend magenta and white India inks for the cherry blossoms. Paint carefully, making sure to not cover burned lines. Use brown India ink for the branches and add white dots to the center of each flower. Paint the border with brown, teal, and magenta India inks. Use dry watercolor pencils to create the background colors, blending from the edges toward the center to achieve the color-fading effect. Use watercolor pencils to color the chickadees. Liquefy the pigments by painting over them with a wet paintbrush until the colors blend together.

- **Finishing touches:** Seal the clock with several coats of a spray-on polyurethane sealer. Install the hands and mechanism—it's *time* to enjoy your clock!

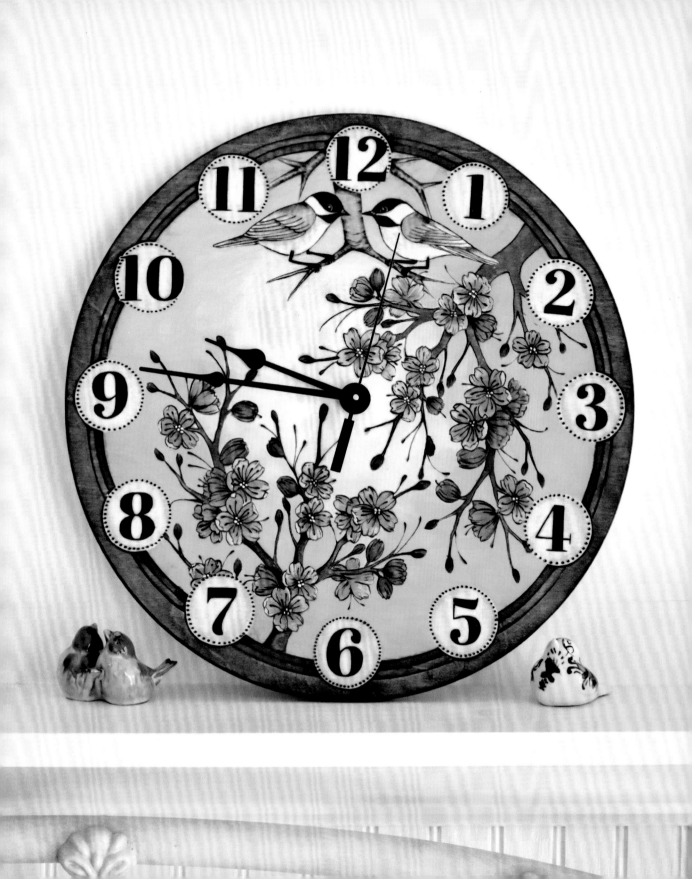

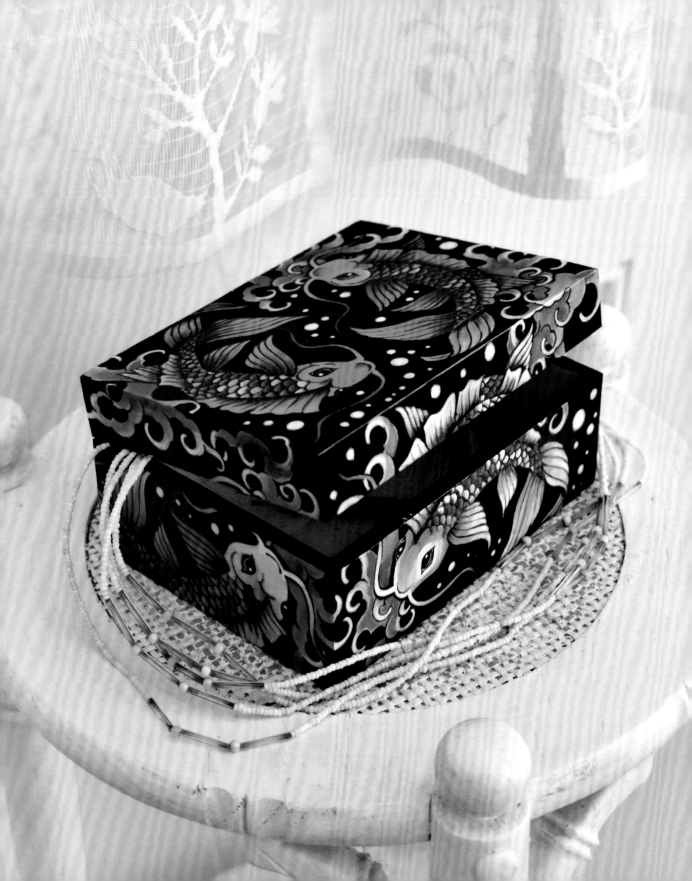

Jewelry Box

Level: **Intermediate**
Template: **Animals (pg. 101)**
Tools Used:

Transfer Tip Angled Shader Writing Tip Spoon Shader

Patience is a virtue with this jewelry box, but the results are absolutely worth it! With a vibrant koi fish design and enough space inside for your favorite keepsakes, this project will test your skills!

What You'll Need:

- Unfinished basswood jewelry box
- India inks
- Watercolor pencils
- Brush-on polyurethane sealer

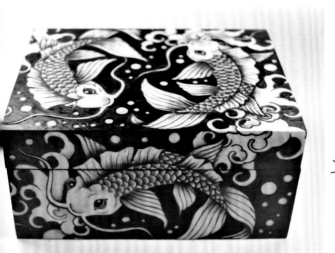

The Process:

- **Before burning:** Print out several copies of the koi template onto translucent paper, cut them out, tape them on the box, and transfer the designs with the heat transfer method and a transfer shader tip. Use a pencil to add the circles to create the bubbles around the fish.

- **Beginning to burn:** Burn the solid black background with an angled shader on medium-high heat. For the smaller details and around tighter curves, you might want to turn down the heat of your burner to avoid any overburn or yellowing of the surrounding wood. Don't worry too much if you experience any overburn on this project because you'll be coloring over the wood.

- **Shading:** Before shading in the koi fish and the waves, use a writing tip to outline all the features of these designs. Once you've burned the outlines, use a spoon shader to create all the gradients. When shading the scales, always shade from the overlapped area outward toward the edge of the scales to create a realistic look. Shade the base of the fins and tails where they connect to the body, shading outward toward the tips. Most of the wave gradient is created using color, so minimal shading is needed.

- **Embellishing:** Add color using India inks. Blend tangerine, orange, bright red, and white to create the colors on the koi and apply them with a paintbrush. Color the waves with dry watercolor pencils and then blend them with a damp paintbrush. Use white India ink for the bubbles and highlights.

- **Finishing touches:** Allow the box to dry for 24 hours before sealing the whole box with a brush-on polyurethane sealer.

When burning a black background behind a complex image, look at your box from several angles every so often to make sure you keep your perspective about the design as a whole. Remember that burning doesn't erase and the outlines are the most important to pay attention to. It's okay to change your mind about your design midway through.

Gourd Birdhouse

Level: **Intermediate**
Template: **Botanical (pgs. 117 & 119)**
Tools Used:

Large Ball Tip Curved Knife Small Ball Tip

Combining art and the natural world can give some pretty amazing results! As you practice your stippling skills, this project will have you daydreaming about the birds who will serenade you in the spring.

What You'll Need:

- Unfinished birdhouse bottle gourd
- India inks
- Brush-on weatherproof exterior polyurethane sealer
- Jute cord

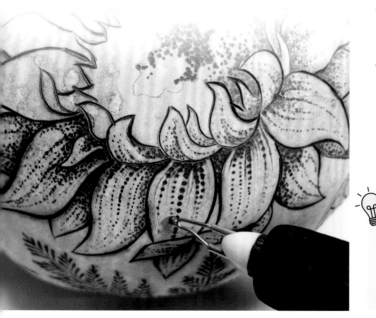

The Process:

- **Before burning:** Several individual templates form the beautiful autumn foliage motif for this gourd: a maple leaf, an oak leaf, a sunflower, and a fern. Individually transfer each template with the tracing method. Draw additional designs by hand with a pencil, following the natural curves of the gourd to fill the space. Drill a few small holes into the bottom of the gourd before burning. This helps with drainage and airflow when a bird uses this gourd to nest in. Also, drill two holes into the top of the gourd for your jute cord to pass through.

- **Beginning to burn:** Use a large ball tip to create a decorative band of black stippling around the entrance hole as well as on the top and bottom. Use a curved knife to create the outlines of the leaves and flowers.

- **Shading:** Shade the foliage with a small ball tip by using the stippling technique. When you're shading with a ball tip, you always want to randomize your dots by going from dark (more dots) to light (fewer dots) to create gradient and texture. The longer you hold your pen in place, the darker and larger your dot will be. Try a lower temperature at first to make sure you build up to the shade you desire.

- **Embellishing:** Paint the background of the gourd with orange and yellow India inks to create a warm autumn glow.

- **Finishing touches:** Let the inks dry completely before sealing the entire gourd with several coats of a brush-on weatherproof exterior polyurethane. Once the goard has fully dried, loop a jute cord through the holes you drilled at the top—and then it's ready to hang!

Because gourds are less dense than wood, you'll want to burn them on a lower heat setting. Your tools will require more frequent cleaning when burning through the top layer of gourd material because of the added buildup that's created. If you keep your tools clean and go slow, you'll end up with a really neat result.

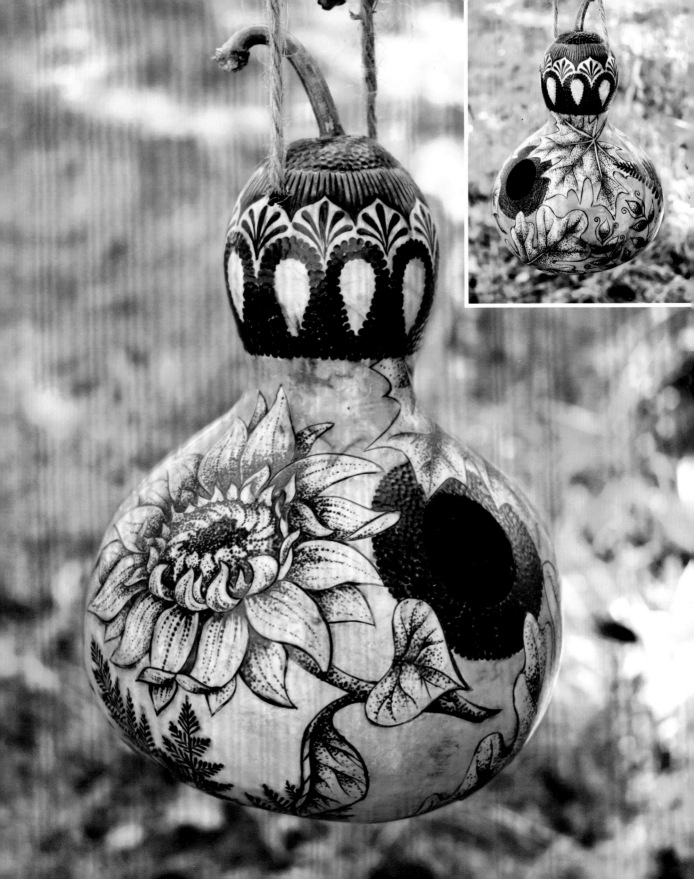

Wall Art

Level: **Advanced**
Templates: **Animals (pg. 99)**
Botanical (pg. 117)
Tools Used:

Spoon Shader Angled Shader Curved Knife Ball Tip

This woodsy wall art is a project for deeper practice in shading and textures. By adding the moonlight seeping through the trees, the simple fox and birch tree silhouettes really come to life.

What You'll Need:

- Basswood plaque (9x12 inches)
- White colored pencil
- Black acrylic paint
- Brush-on polyurethane sealer
- Hook

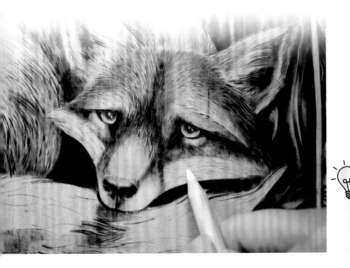

The Process:

- **Before burning:** Tape the fox and birch tree templates onto the wood and transfer the designs with the tracing method. Use a pencil and a ruler to draw the border and add any additional small elements directly onto the wood, including the moon and moonbeams.

- **Beginning to burn:** Burn the inner edges of the border to create a containment for the artwork portion. Use a spoon shader to slowly map out the shading, beginning with the darkest areas of the artwork and blending softly outward toward lighter areas. Start with soft, gradual tones. To create more realism, there's no need to outline anything. Use easily erasable pencil lines and soft shading around the edges of things to coax out the final design with more subtlety and lifelike detail. Use an angled shader and a curved knife to create the fur texture on the fox, using varying strokes and following the direction of the fur.

- **Shading:** Add more layers of shading with a spoon shader until the tones and shadows are just right. Sharpen up any last details with an angled shader. (See the Shading and Fur sections on pages 26–29 and 40–41, respectively, for more information on shading.)

- **Embellishing:** Create the wood grain pattern on the trees in the border with a curved knife and shade with an angled shader. Use a white colored pencil to create highlights on the trees, the white fur on the fox, the moon, and the border. Use black acrylic paint to paint the outer beveled edges of the wooden plaque. Use a ball tip to create the decorative imagery in the square corners of the border.

- **Finishing touches:** Seal the whole artwork with multiple coats of a brush-on ultraviolet-protective polyurethane. Attach a hook to the artwork and hang the plaque where desired.

After burning and before sealing, use a white colored pencil to highlight areas you want to brighten. Color directly onto the wood with firm pressure. For the white fur, the white colored pencil makes a beautiful finishing touch.

Tabletop

Level: **Advanced**
Templates: **Birds** (pgs. 102 & 104)
Bees & Butterflies (pg. 109)
Botanical (pgs. 116 & 118)
Tools Used:

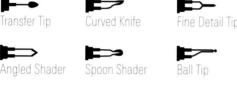

Transfer Tip Curved Knife Fine Detail Tip

Angled Shader Spoon Shader Ball Tip

This project will put your shading skills to great use! This design is for the more advanced woodburning enthusiasts, but you can alter or replace the design to suit your own preferences.

What You'll Need:

- Basswood plaque or a tabletop (16x20 inches)
- India ink
- Wood stain
- Brush-on polyurethane sealer
- Table legs

The Process:

- **Before burning:** Print the templates onto translucent paper with a laser printer. Cut out the templates and arrange them on the tabletop in a pleasing way, making sure the toner side faces down. Tape the templates onto the wood and transfer the designs with the heat transfer method and a transfer shader tip.

- **Beginning to burn:** Use a curved knife for all the straight-ish edges. Use a fine detail tip to fill in the curvy outlines and the areas with trickier, smaller details.

- **Shading:** Carefully shade each element with either an angled shader or a spoon shader. An angled shader is best for getting into tight spaces with ease. I like to glide an angled shader across the surface in one smooth pull. With its curved bottom, a spoon shader excels at blending and creating roundedness to a shape. It works best with small, circular motions. Give the flowers dimension by shading the inner base and the outer edge of the petals and blending them toward the center. Shade the wings of the birds and the edges of the feathers similarly to give them a rounded look and a crisp outline against the light background.

- **Embellishing:** Lightly draw the swirling line with a pencil to tie the flying elements together around the floral centerpiece. Stipple over this line with a ball tip. Brush a mixture of yellow India ink and wood stain onto just the background of the wood, blending from the edges inward and around the flowers in the middle. This adds a pop of color and gives the tabletop a vintage yellow glow that complements the natural look of the burning.

- **Finishing touches:** Brush on four coats of a polyurethane sealer to the surface of the wood, lightly sanding between coats for a smooth, glossy finish. Use a sealer that's meant for furniture and can withstand water and heat. Attach legs to the underside and pull up a chair!

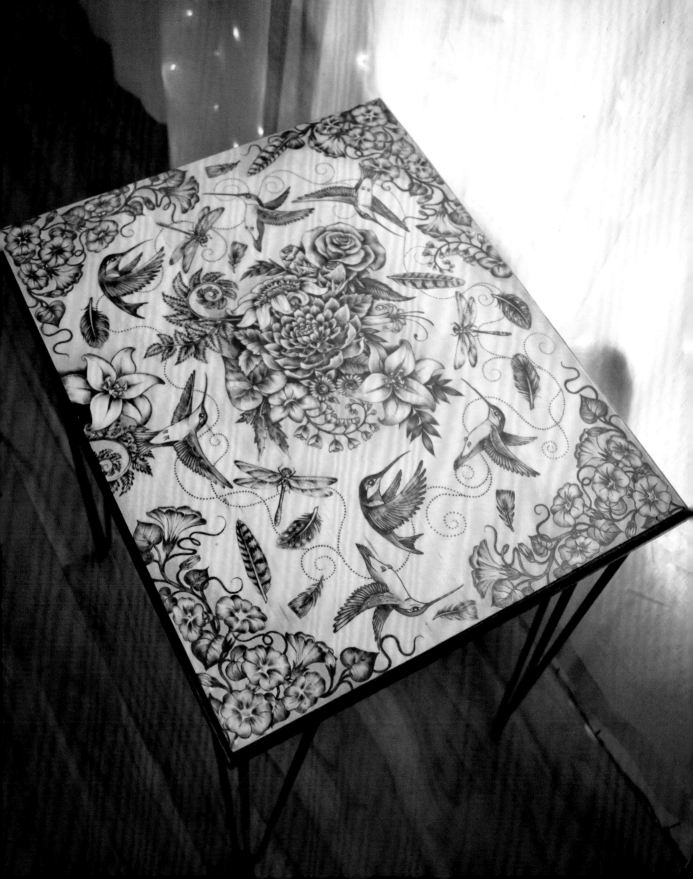

Chapter 3
The Templates

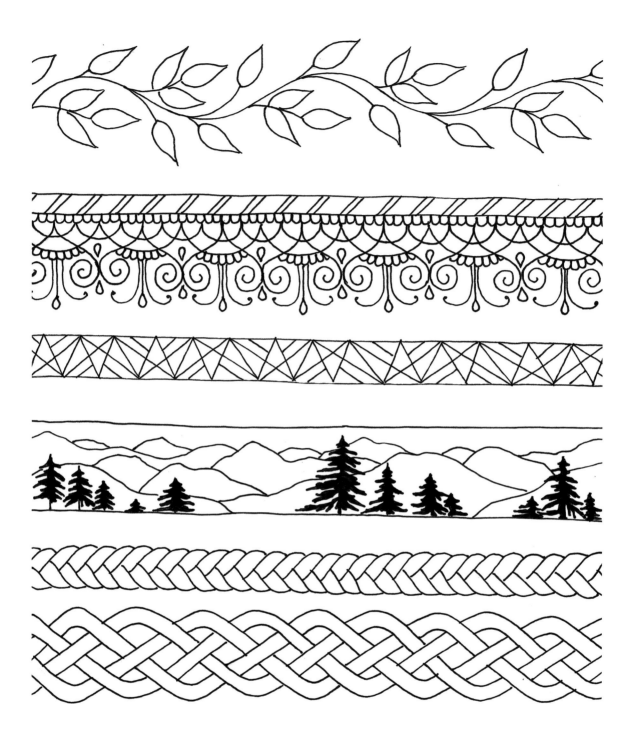

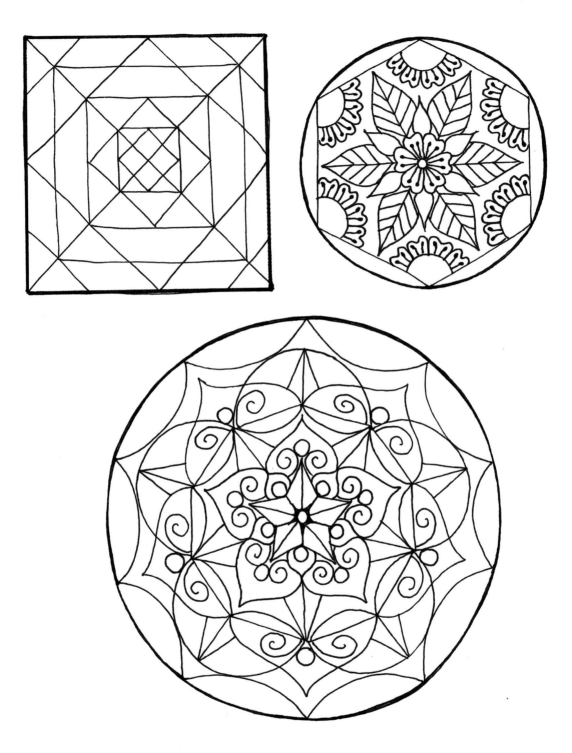

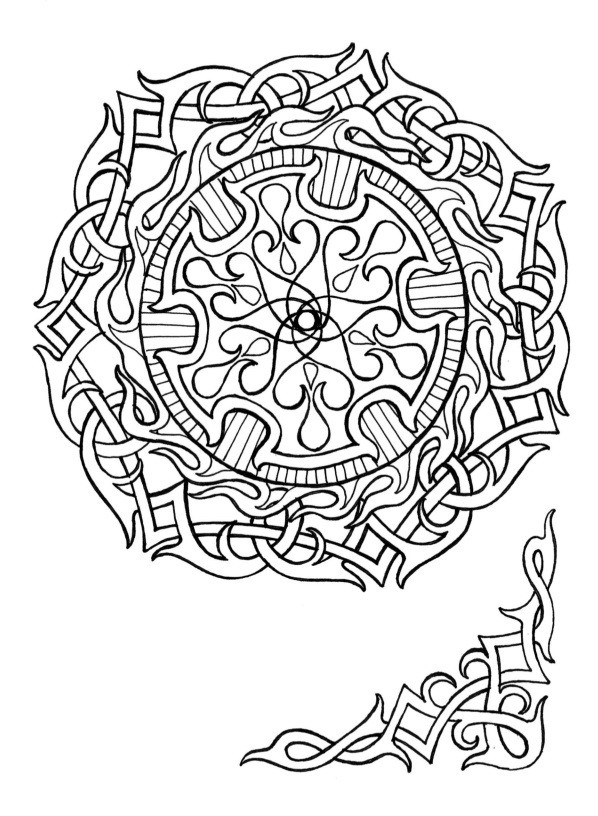

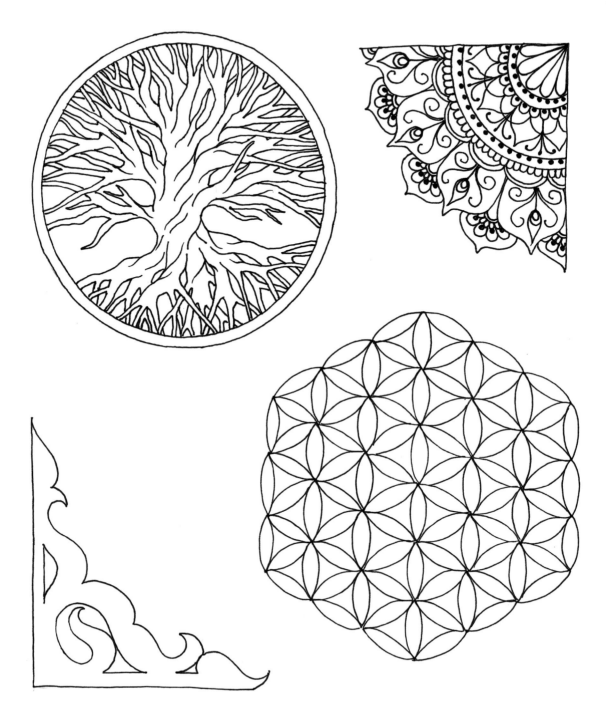

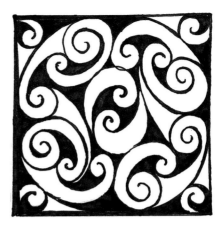

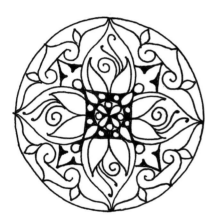

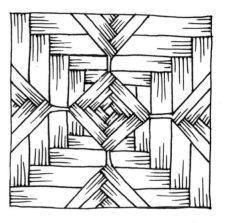

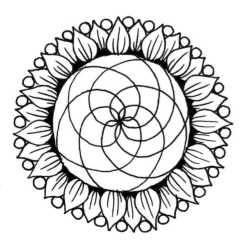

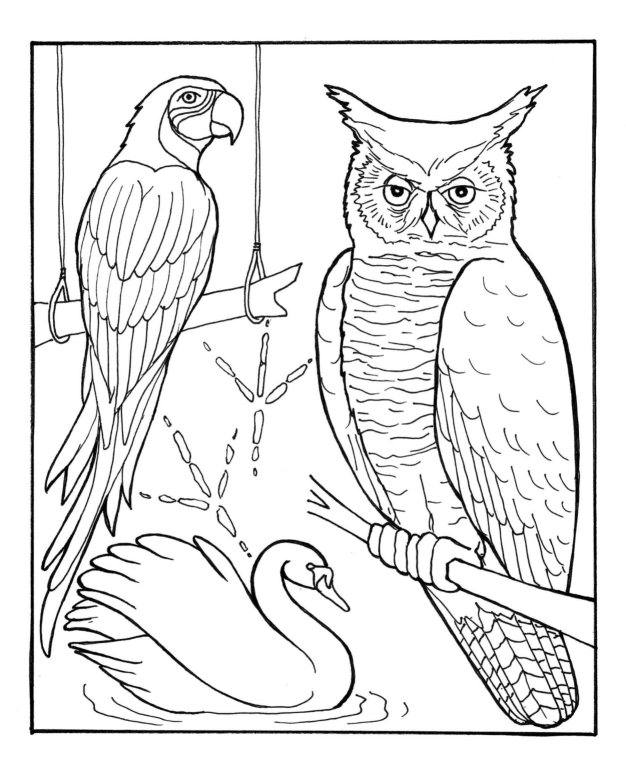

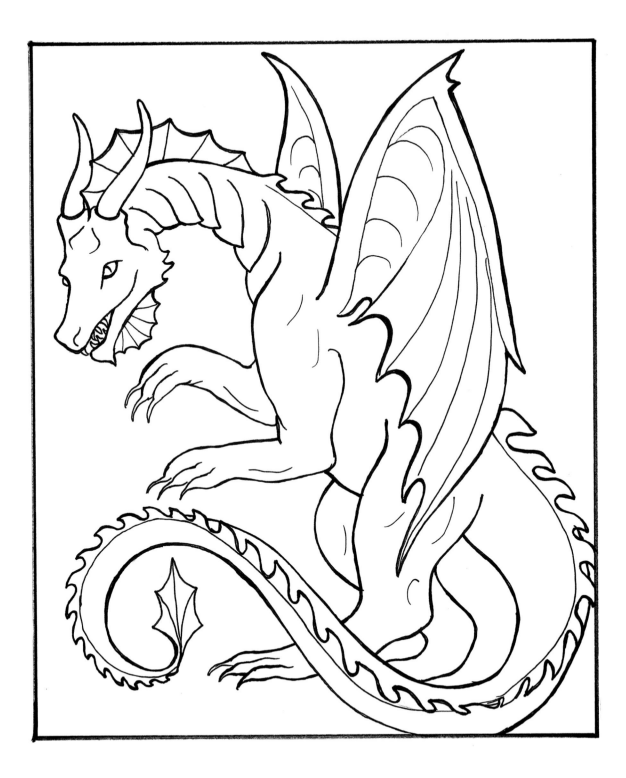

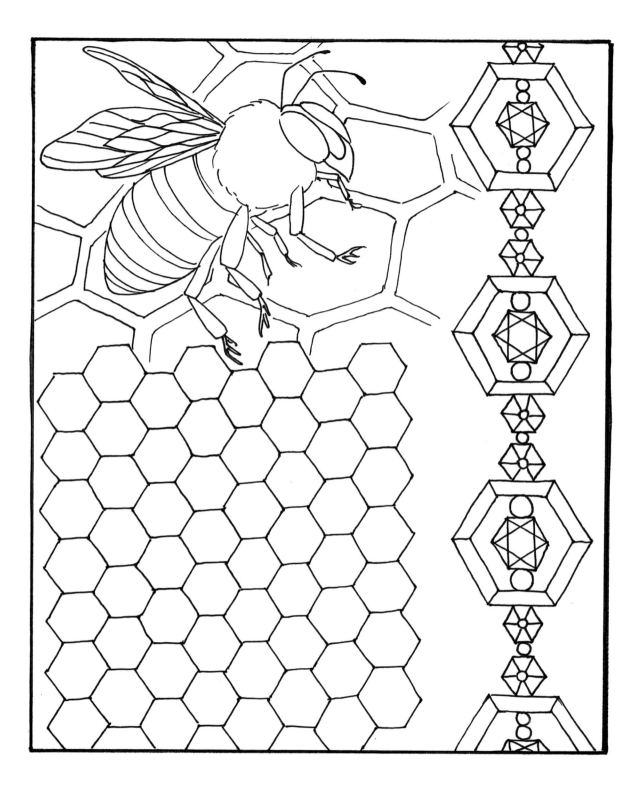

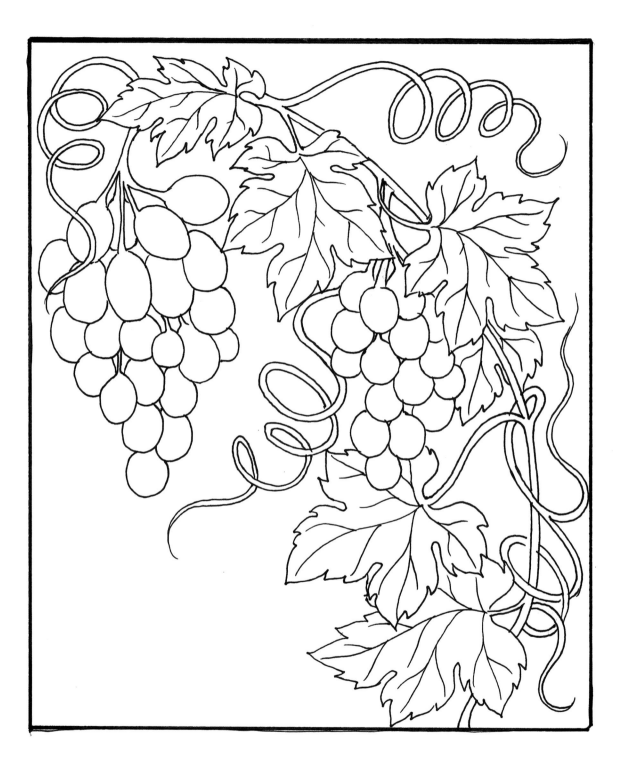

Index

ACKNOWLEDGMENTS

First and foremost, thank you to DK Publishing for trusting me to author *Creative Woodburning* and for fostering creativity worldwide with your award-winning books. It's an honor to be among the many DK authors.

Thank you to my fantastic editor, Christopher Stolle, whose emails have been a steady presence in my inbox the past year and whose dedicated guidance has helped this book grow into the best version of itself. Thanks to our talented designer, Lindsay Dobbs, who has showcased the information in this book in such a beautiful, skillful way. To all the people at DK and Penguin Random House who have worked to make this book a reality, thank you for the opportunity to share my passion for woodburning with the world.

I want to give a wholehearted thank you to Razertip Industries for their generous donation of new tools for the creation of this book. Their superior tools are a delight to use, and the artwork and photographs in this book wouldn't be what they are without Razertip. Thank you for the vote of confidence and willingness to contribute toward this exciting project!

Thank you to the trees for imparting such unique and lovely characteristics into your wood that shall become the natural canvases for woodburning artists everywhere. Each woodburned piece of art was once a living tree. We shall not forget.

Thank you most of all to my family, friends, and loyal customers who have encouraged and supported my artwork over the years. To my daughter, who has given me a reason to work from home and build a creative career and who so joyfully expresses her own inner artist, I thank you. And to my husband, Rob, who bought me my first good pyrography machine, who has always enthusiastically supported my creative endeavors, and who has so graciously made space in our days for me to write this book, I thank you from the bottom of my heart.

I am grateful for the unending inspiration of the natural world and the opportunity to create art every day.

Publisher Mike Sanders
Editor Christopher Stolle
Designer Lindsay Dobbs
Art Director William Thomas
Photographer Bee Locke
Proofreader Martin Zibauer & Penny Stuart
Indexer Eileen Allen

First American Edition, 2020
Published in the United States by DK Publishing
6081 E. 82nd Street, Indianapolis, Indiana 46250

22 23 10 9 8 7 6 5 4 3
003-317284-AUG2020

Published in the United States by Dorling Kindersley Limited.

ISBN: 978-1-4654-9268-5
Library of Congress Catalog Number: 2019950633

Note: This publication contains the opinions and ideas of its authors.
It is intended to provide helpful and informative material on the subject
matter covered. It is sold with the understanding that the author(s) and
publisher are not engaged in rendering professional services in the
book. If the reader requires personal assistance or advice, a competent
professional should be consulted. The authors and publisher
specifically disclaim any responsibility for any liability, loss, or risk,
personal or otherwise, which is incurred as a consequence, directly or
indirectly, of the use and application of any of the contents of this book.

Trademarks: All terms mentioned in this book that are known to be
or are suspected of being trademarks or service marks have been
appropriately capitalized. Alpha Books, DK, and Penguin Random
House LLC cannot attest to the accuracy of this information. Use of
a term in this book should not be regarded as affecting the validity
of any trademark or service mark.

DK books are available at special discounts when purchased in bulk
for sales promotions, premiums, fund-raising, or educational use.
For details, contact SpecialSales@dk.com.

Printed and bound in China

All other images © Dorling Kindersley Limited
For further information see: www.dkimages.com

A WORLD OF IDEAS:
SEE ALL THERE IS TO KNOW

www.dk.com